15h

TIEPOLO

The life and work of the artist illustrated with 80 colour plates

FRANCESCO CESSI

THAMES AND HUDSON

Translated from the Italian by Pearl Sanders

This edition © 1971 Thames and Hudson, 30-34 Bloomsbury Street, London WC1
Copyright © 1969 by Sansoni Editore, Firenze.

Printed in Italy

ISBN 500 41041 0

Life

The war with Turkey entailing the loss of Crete (1669), the last heroic endeavour in the military history of the Venetian Republic, came to an end almost thirty years before Giambattista Tiepolo's birth. It was a war fought with bravery, but had nevertheless ended in an irreparable defeat for Venice, and, of course, for her Exchequer. Now that the routes to the East were barred to her, the Republic moved slowly but steadily towards her decline.

The interests of the European powers were tied to the houses of Hapsburg and Bourbon, through their alternating fortunes in the course of three wars of succession (Spanish, Polish and Austrian), and impinged only marginally upon the Venetian Republic. It was precisely for this reason that Venice had become too sure of her position and her Italian territories. Her trading and seafaring nobility settled down to enjoy a life of ease on their estates and were too often forgetful of the achievements of the early years of colonization; and the less they were concerned with strategic security, the more ostentatious their way of life became.

Between 1745 and 1750, Giambattista Tiepolo, by then an established artist, painted for the Ducal Palace in Venice a picture entitled *Neptune offering to Venice the riches of the sea*. This was no empty assertion of past glory, but, rather, a heartfelt tribute to the existing grandeur of a state which, half a century later, was to disappear. It was a tribute expressed, moreover, without any false rhetoric, in the grand manner of sixteenth-century Venetian art, and bore witness to the flourishing economic and intellectual life of the Republic which could well compensate for the strategic and commercial privileges she had already forfeited. In the days of her decline, Venice had found in Tiepolo the artist who could do her full justice. By the magnificence of his creations he perpetuated the illusion that the world of Venice's glory would last for ever: in fact it was only by drawing upon its past greatness that this world gained the

strength to survive, and to die in a way which was worthy of it.

Giambattista Tiepolo was born in Venice in 1696, probably on 5 March, the son of Orsola and Domenico. His father, who belonged to a well-known family, was co-proprietor of a merchant vessel. He died when Giambattista was only a year old, leaving his wife to administer the family property and educate her six young children. Giambattista was apprenticed to the painter Gregorio Lazzarini, who lived in the parish of San Pietro in Castello, where the Tiepolo family also lived. Lazzarini taught the young artist the rudiments of drawing, perspective and composition. In particular, he showed him how to set about arranging complex groups of figures in vast pictorial compositions, and how to enhance the whole by iridiscent effects of colour.

However, what Lazzarini taught Tiepolo was very much based on the style of seventeenth-century Venetian art, and this traditional approach could not satisfy the young man's search for a personal means of expression. We are told by his biographers that he was more interested in what was being done by some of his contemporaries, who were at that time enjoying considerable success in Venice: Giambattista Piazzetta, who was greatly influenced by the dramatic style of painting of Giuseppe Maria Crespi and the school of Bologna in general (whose effects were achieved mainly by means of chiaroscuro); Federico Bencovich, known as Federighetto; and Sebastiano Ricci, whose use of colour he particularly admired. But at the same time Tiepolo found he became more and more drawn to the great artists of Venice's past: to Titian and Tintoretto, and above all to Veronese.

Giambattista's career began early. By the age of eighteen, he was entirely independent, and when he was twenty-one, in 1717, he became a member of the Fraglia, the guild of Venetian painters. He received his first commission when he was only nineteen, to paint over the niches in the church of the Ospedaletto, and his early biographers could see that he had already abandoned the ' painstaking ' manner taught him by Lazzarini, and had adopted a ' resolute and

4

rapid ' style. From this time on, his career could almost be said to be monotonous – a succession of commissions and their execution – if it were not for the amazing vitality which led him to search constantly for new and original means of expression. Although occasional signs of tiredness did appear, only natural in such a vast output, this search was tenaciously pursued over a span of more than fifty-five years.

The stages in Tiepolo's development can be traced by certain important events in his career. His first taste of success came at the age of twenty, when he was applauded by both critics and public for his painting *Crossing of the Red Sea.* This was painted in competition with other artists and exhibited in public outside the Scuola San Rocco, famous for the paintings of Tintoretto which cover its walls. This success was followed by others, and soon Tiepolo received his first really important commission, to paint a fresco for the vault of the side chapel in the Scalzi church in Venice, the *Glory of St Teresa.* This work, dated about 1720-5, marks the beginning of Tiepolo's happy collaboration with Gerolamo Mengozzi-Colonna, an artist of the Bologna school, who specialized in architectural perspective effects (*quadratura*). It was only Tiepolo's departure for Spain, in 1762, followed soon after by the death of Mengozzi-Colonna, which brought their partnership to an end. The importance of this association to Tiepolo's art is undeniable: it encouraged him to pursue still further his research into a new spatial conception, which not only resulted in his own virtuosity, but led to a new interest in the painting of skies.

Church commissions were followed by commissions for private persons – for works on a variety of subjects, mainly secular. One of Tiepolo's most important assignments was given by Doge Cornaro, who entrusted him with the supervision of the pictorial decoration of his palace at San Polo. (This must have been some time before 1722, when the Doge died). There followed the decorations for the Palazzo Sandi (1722-5), a task which led to a change of direction in Tiepolo's life and artistic career.

Soon afterwards he was summoned to Udine to decorate

the new section of the archiepiscopal palace, the Palazzo Dolfin. He began work on his frescoes for the palace in about 1725, with the help of assistants, and while he was there he also painted the ceiling of the Chapel of the Holy Sacrament in the Cathedral. That he should have been entrusted with this task not only indicated the fame he had now achieved, and that a school had grown up around him, but also led to a fundamental turning-point in the development of his style.

Now, at the age of thirty-five, Tiepolo was able to return to Venice, surrounded by success and secure in the knowledge that his fame would increase, extending far beyond the confines of the Venetian Republic. In 1731, in fact, he was asked to go to Milan, to paint frescoes in the Archinto and Casati palaces. Nothing remains of the four ceilings he executed in Palazzo Archinto, which was destroyed during the last war, but in Palazzo Casati, later known as Palazzo Dugnani, the decoration of the great hall can still be seen.

On his return to Venice in 1732, Tiepolo was fully occupied by a series of religious canvases. In the autumn of that year, he left for Bergamo to fresco four allegorical figures in the cupola of the Colleoni Chapel, and he returned there a year later to paint in the chapel itself some scenes from the life of St John the Baptist. At the same time, he painted three large canvases for the Villa Grimani-Valmarana at Noventa Padovana (now in separate collections) as well as an altarpiece for the parish church of Rovetta sopra Bergamo, *The Virgin in Glory, adored by apostles and saints*. There followed three canvases, painted as a triptych, for the Venetian church of Sant'Alvise (*Road to Calvary, Flagellation* and *Crowning with thorns*). Other works, painted in Venice and outside – at Verolanuova and on Lake Como (Villa Girola) – belong to this period before 1740.

By 1736 Tiepolo's fame extended far beyond the Alps: Count Tessin, the Swedish ambassador to Venice, sent his *Danaë* to Stockholm; Count Francesco Algarotti, the arbiter of contemporary taste, expressed admiration for his art, and he was never without work. In 1737 he began the

decoration of the ceiling of the Gesuati church in Venice. which he concluded in 1739, when he had already been given the commission to paint the ceiling of the Scuola del Carmine. He returned to Venice later to carry out this commission, but in the meantime he went back to Milan, at the request of the Marchese Giorgio Clerici, general of the Empress Maria Teresa, to fresco the ceiling of the Palazzo Clerici. His success was so great that an anonymous poet wrote a number of poems in his praise, giving him the title *imitatore di Paolo Veronese*.

By the time Tiepolo returned to Venice, his fame was such that no family of any standing was willing to forgo his services. He was the great new star of Venetian art, and through him the past splendour of Venice was revived. He continued to paint in the Scuola del Carmine, and did other paintings at the same time. In 1743, he returned to the Scalzi church, where he covered the entire ceiling of its single nave with a fresco, *The Miracle of the Holy House of Loreto*. This work, too, was highly praised; unfortunately, it was completely destroyed by bombing in 1915. Tiepolo left Venice again, to work in fresco in the Villa Cordellina, at Montecchio Maggiore near Vicenza. During this period his relations with Count Algarotti became closer, and the Count, who at the time was the representative of King Augustus III of Saxony, suggested that he should do some paintings for the king. At the same time he was working on canvases for the Barbaro and Cornaro families, and shortly afterwards, with the assistance of Mengozzi-Colonna, he began work on frescoes for the Palazzo Labia at Cannaregio. Also dating from this period, 1745-50, are *Neptune offering to Venice the riches of the sea*, the picture, already mentioned, which he painted for the Ducal Palace in Venice, and the *Martyrdom of St Agatha* (now in Berlin), which he painted for the church of Santa Agata in Lendinara (Rovigo) – a subject he had already treated in an altarpiece in the Santo in Padua. Somewhat later came the commemorative painting *Consilium in Arena*, commissioned by Count Montegnacco of Udine, in which Tiepolo's son Giandomenico appears to have collaborated.

In 1719 Giambattista had married Cecilia Guardi (the sister of the artists Antonio and Francesco). They had nine children, two of whom, Giandomenico (born in 1727) and Lorenzo, became painters. Giandomenico entered his father's studio as his personal assistant. When he was twenty-three, and Lorenzo fourteen, Tiepolo took them with him to Würzburg. He had been asked to go there in 1750 in order to fresco the Kaisersaal, the great hall of the Residenz, the Prince-Bishop's new palace, which was being built by the architect Balthasar Neumann. The German banker Mehling had carried out the negotations in Venice between the Prince-Bishop, Carl Philipp von Greiffenclau, and the artist. Tiepolo reached Würzburg in December 1750; he was accompanied by his two sons and the Venetian stuccoist Felice Bossi. He began work on the Kaisersaal (completed in 1752), and was so successful that he was given a contract to paint the ceiling of the staircase as well (1753).

In his three years' stay in Würzburg, Tiepolo accomplished some of his greatest work. His 'influence on German art was considerable, and he himself benefited from the stimulus of new ideas. He left Würzburg in 1753. In spite of the vast undertaking on which he was engaged, he found time during his stay to do some paintings in oils – a technique he never abandoned. Some were painted for the Benedictine monks whose church and monastery at Schwarzach had recently been built by Neumann, others for the castle of Bückeburg. Other works executed in Germany during this period and ascribed to Tiepolo should more correctly be attributed to his son Giandomenico, or to the German artists who were engaged as assistants for the decoration of the Bishop's Palace at Würzburg, especially Georg Anton Urlaub and Lucas A. Flachner.

On his return to Venice, laden with honours, Tiepolo found that the experience he had acquired in Germany could be applied in the new works he was commissioned to paint. He soon returned to his rhythm of work, and continued in his many huge undertakings. He decorated the Villa Soderini at Nervasa, Treviso (now destroyed), assisted by Giandomenico and by Francesco Zubno, and,

slightly later, frescoed the ceiling of the Pietà church in Venice (1755).

The decoration of the Palazzina and Stanza dell'Olimpo at the Villa Valmarana, Vicenza, was done in 1757. At about the same time he painted the ceiling of the principal room in the Palazzo Valmarana-Trento, Vicenza (destroyed), and in 1758 he frescoed two rooms of Palazzo Rezzonico, Venice. In 1759, there followed two major works: the *Assumption*, painted in fresco in the church of the Purità, Udine, and the great altarpiece of *St Thecla* for Este Cathedral. The last works Tiepolo painted in Italy were produced in 1761: notably, the ceiling of Palazzo Canossa, Verona (destroyed during the last war), where he was assisted by the Milanese ornamentalist Visconti, and the *Apotheosis of the Pisani Family*, painted for the Villa Pisani at Strà, between Venice and Padua.

It was while he was engaged on this last work that Tiepolo received an invitation from Charles III of Spain to decorate the new royal palace in Madrid, the Palacio de Oriente, built to the plan of the Turin architect Giovanbattista Sacchetti. With Giandomenico and Lorenzo he travelled by land from Venice. He set out at the beginning of April 1762, leaving his other son Giuseppe, a priest, in charge of the family affairs. He reached Madrid on 4 June, ill and tired after his long journey, and went straight to bed. He had brought with him a plan for the ceiling of the throne room, and as soon as he was strong enough, set to work. The ceiling was completed in 1764, and he painted two others in the palace between then and 1767. When all his work in the palace was completed, Tiepolo offered to remain in the King's service, and asked to be given further commissions. Unfortunately, he had an enemy at court, the King's confessor, Padre Joaquim de Electa, who favoured Anton Raphael Mengs, a German artist who followed the neoclassical theory of Winckelmann and was present at court at the same time as Tiepolo. Thus Tiepolo's last years in Spain were sad ones. Admittedly, he was able to obtain, through the good offices of the Italian architect Antonio Sabbatini, who had just finished building the church of San Pascal at Aranjuez, a commission to paint

seven altarpieces for the church. But when they were ready, Padre de Electa refused to receive Tiepolo; and shortly afterwards he had them removed from the church, and replaced by works by Mengs, Bayeu and Maella. The paintings were dispersed, but fortunately they have all been traced, though some of them are mutilated. Although at the end of his life Tiepolo found himself misunderstood and the victim of intrigue, he maintained his extraordinary output; among the works of this last period are the alterpiece *St James of Compostela on Horseback* (now in Budapest), oil paintings sent to Russia to decorate the ceilings of palaces, and a remarkable group of small religious canvases commissioned by local families.

Since in Madrid Tiepolo did not enjoy the acclaim he had received at Würzburg, it was not possible for him to gather a school of painters around him; yet, more than his rival Mengs, it was he whose influence roused an echo in the artists of Spain, not only penetrating the circle of his rivals (in Maella and Bayeu), but inspiring López' decoration of the Royal Chapel and stimulating the imagination of the young Goya.

Tiepolo died suddenly in Madrid on 27 March 1770. Giandomenico returned to Venice soon after; Lorenzo remained in Madrid, but survived his father by only a few years. The church in which Tiepolo was buried, his parish church of San Martín, was later demolished, and even his tomb has disappeared; yet his art remains alive.

Works

Pallucchini (1960) has pointed out that ' the art of the late seventeenth-century *tenebrosi* acquired renewed meaning in the dramatic power, achieved by means of a violent chiaroscuro, of the Bencovich-Piazzetta-Tiepolo group ', who, in a sense, represent ' the last descendants of Caravaggio . . . translating and interpreting his innovations according to the taste of Venice '. The truth of this statement is confirmed already in Tiepolo's earliest works, and even his first biographers provide proof of it. Da Canal (1732) relates that Tiepolo soon abandoned Lazzarini's ' painstaking ' manner, since being ' all spirit and fire ', he quickly acquired a style much more ' resolute and rapid ' than that of his master. To illustrate his point, he goes on to refer to ' the *Apostles*, which, at the age of nineteen, he painted over the niches of the church of the Ospedaletto '. Da Canal was mistaken in calling these figures *Apostles*; they should, in fact, be identified as the two figures of the *Sacrifice of Abraham*. The treatment is so vigorous that it is hard to believe it was the work of such a young artist. Although the influence of Bencovich can clearly be seen, the colour is much more vivid and warm. Bencovich and Piazzetta were the original sources for Tiepolo's new art, as was noted by Gianantonio Moschini (1806), who stated that, ' eager to imitate whatever was popular in his own day, he emulated now the showy manner of Bencovich, now the strong shadowings of Piazzetta '. And this description is a fair one, although it omits what had been one of Tiepolo's distinguishing features from his earliest years, his continuous interest in new means, as well as his temperament of ' spirit and fire ' which Da Canal had observed. These gifts led him to seek out a personal mode of expression, even while adhering to the post-*tenebrosi* style of Piazzetta and Bencovich.

It is interesting to follow the course of Tiepolo's early career, and to see how his first preferences matured into integral parts of his personal language. We see, in the

Repudiation of Hagar (Milan, Rosini collection), for example, a work painted only slightly later than the *Sacrifice of Abraham*, that he showed a marked taste for cold tonalities – in contrast to the warm reds preferred by Piazzetta – while at the same time accepting Piazzetta's principle that chiaroscuro was the means of giving relief to the figures; and all this against a landscape which uncannily foreshadows those of the romantic school, built up on a diagonal structure.

Soon after this (about 1721), Tiepolo painted for the church of San Stae, in Venice, the *Martyrdom of St Bartholomew*, a work obviously influenced by Piazzetta but with the new elements of a desire for balance, for ' correspondences ' among the parts, and a more dynamic and expressionistic treatment which heightens the dramatic effect of the figures. One cannot yet identify with any certainty the influence of Sebastiano Ricci, who had returned to Venice in 1717, but it was probably due to him that Tiepolo became aware of the modernity of Veronese's colour.

In about 1722, Tiepolo painted a huge canvas, the *Our Lady of Carmel with souls in Purgatory*. This is a monumental work, conceived in the grand manner; the forms are emphasized by a violent light, and the colour is rich and varied. The principal group of the Madonna is placed to the right, and the whole composition appears unbalanced until one remembers, as Morassi (1955) has explained, that the canvas was designed to be seen foreshortened, being originally intended for the choir at Sant'Aponal. We see here how early Tiepolo began to develop as the creator of perspective effects.

Between 1720 and 1725 (Morassi, 1955), Tiepolo painted in fresco the *Glory of St Teresa* for the Ruzzini Chapel in the Scalzi in Venice (*pl. 1*). Pallucchini (1960) suggests that it came chronologically between the Palazzo Sandi paintings and those for Palazzo Dolfin at Udine, since the fresco shows, in comparison with the Palazzo Sandi frescoes, ' progress of a technical nature ' and ' greater mastery in the arrangement and gradation of the figures, gathered in from below and graduated in proportion to the receding clouds'. He finds that the pyramidal group formed by the Saint

and angels bears ' an undeniable resemblance ' to Piazzetta's *St Dominic* on the ceiling of the church of Santi Giovanni e Paolo, but that in other respects, notably the new luminosity of Tiepolo's colour, the two works are widely different. He explains this divergence in terms of the artists' respective modes of working: while Tiepolo completed his fresco rapidly, Piazzetta, working in the medium of oils, proceeded much more slowly.

For my part, I think that the fresco for the Scalzi chapel may well have preceded the Palazzo Sandi frescoes (later than 1722 and before 1725); and this reopens the whole question of whether Tiepolo's stylistic dependence upon Piazzetta is not too much taken for granted, at least after the strictly initial period of his activity. The *Allegory of the power of eloquence*, painted on the ceiling of the Palazzo Sandi (a sketch in a private collection in Zurich was published by Morassi), shows an unprecedented boldness in opening up the vaults of heaven; only the assured hand of a master could have been capable of this, and it is absent from the Scalzi fresco. The earlier date of this fresco seems even more likely when one remembers that Mengozzi-Colonna was responsible for the organization of the theatrical perspective of the work. Admittedly, the Christian empyrean of the Scalzi ceiling is treated with greater impetus and freedom than the pagan empyrean of the Palazzo Sandi *Allegory*; but the latter, a vortex of figures and ' perspective ' light treated perhaps more prudently, already opens out into spatial concepts never previously attempted. The allegory falls into four episodes (*Orpheus reclaiming Eurydice from Hades, Amphion's music raising the walls of Thebes, Perseus on Pegasus killing the monster, and Hercules and the chained Cercopes*), while in the centre of the ceiling is *Minerva, protectress of the arts, and Mercury*. Less successful are the canvases painted for the walls of the room (now in a private collection), which, as Morassi points out, hark back to seventeenth-century modes.

Tiepolo's activity at Udine (about 1725-8), during which time he completed the decoration of the gallery of Palazzo Dolfin, was, in the words of Pallucchini (1966), one of the

most brilliant periods of his career, ' the moment when he was throwing off the chiaroscuro of Piazzetta, to turn his extraordinary gift for colour in the direction of the rococo '. Also dating from this time are his frescoes for the Chapel of the Holy Sacrament in the Cathedral of Udine (1726). The cupola did not lend itself to ' heavenly expanses ', so he populated it with figures of angels, painted with an intensity of expression which suggested to Pallucchini (1960) that he had been indirectly influenced by Dorigny, some of whose frescoes the cathedral contained.

The new element – almost a change of direction – in Tiepolo's style, which became apparent during his activity at Udine, made its appearance for the first time in the decoration of Palazzo Dolfin (*pls 2-11*). This work may have been begun, as Morassi suggests, simultaneously with the frescoes in the Chapel of the Holy Sacrament, or later, as Rizzi believes. On the ceiling of the staircase he painted in fresco the *Fall of the Rebel Angels,* without doubt the earliest of these works. The theatrical treatment, with Lucifer hurled out of the frame moulding (some sections being modelled in stucco), follows the baroque tradition of the schools of Bologna and Rome. In the frescoes painted for the Gallery, however, Tiepolo evinced an amazing originality. With the assistance of the *quadraturista* Mengozzi-Colonna for the perspective effects, Tiepolo painted in fresco episodes from the lives of Abraham, Isaac and Jacob. The first section on the wall represents *Three angels appearing to Abraham*; the central section, *Rachel hiding the idols*; the third, *Angel appearing to Sara.* On the ceiling: the *Dream of Jacob, Hagar in the desert* and the *Sacrifice of Abraham*, the last of which should be compared – or rather, contrasted – with the painting of the same subject in the lunette of the Ospedaletto church in Venice, done when the artist was a young man. In these works colour is given ' the greatest luminosity, while the integrity of form is preserved ' (Pallucchini). In some of the paintings, for example *Three angels appearing to Abraham*, one of the elements of Tiepolo's new invention is to be seen in the contrast between the figure of Abraham, a vigorous, sculptural form, its massiveness accentuated by

the dark colour, and the brilliant angels in their silk robes, over which the light creates effects of lightning. The influence of Veronese is apparent in the colour employed in the *Angel appearing to Sara*; and in fact the frescoes Veronese painted in the Villa Maser (near Vicenza) are an obvious source, even to the sixteenth-century costume worn by the angel; Veronese's technique of using complementary colours for the purpose of contrast is adopted by Tiepolo and boldly carried to its extreme results.

In the episode *Rachel hiding the idols*, the light reverberates over the group formed by Laban, Jacob and Rachel, but without detracting from its plastic solidity; the reflections of the light must certainly have been studied from life, in Tiepolo's research into a new 'atmospheric' style. The Venetian manner of eighteenth-century landscape art, and even more modern styles, are foreshadowed in the elements of detail, where there is a lyrical, Arcadian feeling. In the same palace (Sala Rossa), Tiepolo frescoed the *Judgment of Solomon*; here he was faced with new problems of perspective, and painted foreshortened figures seen from below in order to compensate for the low height of the room. Here again Veronese is recalled, not only in the colour, but also in the distribution of the figures in space (*pls 9-11*).

During the time of Tiepolo's activity at Udine, 'the revelation of a luminous colour, connected with so vibrant and almost expressionistic a conception of form . . . is the new tone which colours Tiepolo's style' (Pallucchini, 1960). Further evidence of this is provided by some of the small paintings on canvas, such as the *Temptations of St Antony* (*pl. 12*), formerly in the Caiselli collection, Udine, and executed at Udine about 1726-7 (Rizzi, 1966).

Immediately after Tiepolo's first stay in Friuli, he was commissioned to decorate the Venetian palace of Ca' Dolfin. He produced ten large canvases (now dispersed: two in the Vienna Kunsthistorisches Museum, three in New York and five in Leningrad) on historical subjects. Although some of the less successful of these show a certain falling-off of inventiveness, new elements are present which represent a more advanced stage in his style than had been reached

at Udine, considerable as that too had been. Pallucchini (1960) observed that in the canvases painted for Ca' Dolfin there was reached ' a delicate stage in the development of Tiepolo's style: the transition from expression through chiaroscuro to expression through colour, activated by a broad luminosity '. We cannot exclude the possibility that this further stage in Tiepolo's stylistic evolution was suggested by the painting of Giannantonio Pellegrini.

Once Tiepolo had entered upon this path, with his extraordinary inventive facility which enabled him – it could almost be said day by day – to renew his visions of skies symphonically orchestrated in the purest scales of colours, lights and reflections, he painted in Milan frescoes for Palazzo Archinto (now destroyed) and Palazzo Casati (1731). In the latter the subjects, as at Udine, were historical, with no attempt to reconstruct the background or costumes of the period, but with the costumes of the sixteenth century, in the manner of Veronese. The whole treatment was theatrical, with grand gestures emerging from the baroque *quadratura* of the walls. Yet Tiepolo's exuberant imagination never lost contact with reality – in fact, his contact with it was often painfully intense. He remained within the realm of humanity, and the characters he portrayed, far from being anonymous figures or actors playing a part, often give the impression of living portraits.

A group of paintings executed about 1732, when Tiepolo had returned to Venice, seems to illustrate a rather romantic return to some of his youthful preferences, possibly because he again came under the influence of the art of Piazzetta, which had remained faithful to the violent contrasts of chiaroscuro. Belonging to this period are such works as *Abraham visited by the Angels* and *Hagar and Ishmael* in the Scuola San Rocco (*pl. 14-15*), and the *Education of the Virgin* in the Chiesa della Fava (*pl. 16*).

Probably at this same period he painted a series of small canvases such as the *St Roch* in Castello di Zoppola (*pl. 17*), which reveal a depth of religious emotion. The paintings are made up of gentle harmonies of greys and browns, into which are inserted sparkling patches of red, blue or yellow.

In 1732 Tiepolo again set off on his travels, this time for Bergamo where he frescoed four allegorical figures in the cupola of the Colleoni Chapel. These show ' great freedom in the treatment of the decoration and ... a more accentuated clarity of colour, while preserving the plastic integrity of form ' (Pallucchini, 1960). His success was marked by general acclaim and led to his recall to Bergamo the following year to paint three frescoes, again in the Colleoni Chapel, representing episodes in the life of St John the Baptist. He had now elaborated the principles which were to condition his whole career – although at some times less so than others – and achieved the position of honour which he was to retain, both inside the Venetian Republic and beyond, until the sad last years which he spent in Spain.

It may be true that his painting was not always expressive of emotion; yet we cannot fail to be astonished by the facility with which he attained a grand manner. His was the special merit of interpreting a particular moment in the history of Venetian culture, and although this moment may not in all respects have been as great as he showed it to be, at least in the sphere of art it was certainly not over-valued.

From the time of the *St John the Baptist* series in Bergamo, Tiepolo's figures appear much more precisely individualized, while his landscape creates an illusion of *plein air*, an early foreshadowing of the open-air painting of the French realist and impressionist schools. These new elements are not to be sought so much in his vast frescoes as in the *modelli*, detailed small-scale versions prepared in advance for his clients' benefit. In the *modelli* produced during the Bergamo period we find a greater spontaneity and expressiveness than in previous examples, with the figures boldly outlined.

Tiepolo completed the frescoes in the Villa Loschi, near Vicenza, in an extraordinarily short time. The subjects were allegories of a secular nature. With a superb sense of the theatre, he showed his characters as individuals in their own right, not hampered by the demands of the scenario, as in some of the more pompous works he sometimes

painted. Belonging to the same period (about 1734) are the *Martyrdom of St Agatha*, painted for the Basilica del Santo, Padua, and *The Virgin in Glory, adored by apostles and saints*, for the church of Rovetta sopra Bergamo. In the former work, the scene of the martyrdom is presented with restraint, in subdued colours; in the latter, the colours become warmer, vibrant and luminous in the manner of Veronese and Ricci, while the composition follows a broader plan, in the contrast between the earthly and heavenly figures, both groups connected and contrasted by the fluted column placed to the left in order to break up the geometric shape of the foreground group.

Tiepolo's ever closer adherence to Veronese (even though with overtones of Ricci) was not overlooked by his contemporary critics (Zanetti, 1732, and Tessin, 1736). It can be seen at its most successful in such works as the frescoed ceilings in the Gesuati church (Santa Maria del Rosario) in Venice (*pls 19-20*), where this aspect of Tiepolo's style appears most completely integrated. The influence of Veronese is especially obvious in the large section representing *St Dominic instituting the Rosary*, where the perspective was modelled on an example by this master, strongly foreshortened from below, with groups of figures standing out in sculptural relief to give a sense of depth; Tiepolo's personal ' touch ' appears in a skilful play of light among the dark clouds of the sky, with its contrasting masses of dense shadow and an almost blinding light.

This movement upwards towards the light, that is, towards the ' heavens ', which Tiepolo introduced on the example of Veronese, was carried out even more successfully in the frescoes painted in the Palazzo Clerici in Milan (1740), praised by Tiepolo's contemporaries as the work of an ' emulator of Paolo Veronese ' (*pls 26-31*). Morassi (1955) rightly observes that Tiepolo adopted a ' centrifugal ' system in this composition: the figures, placed along the edges of the ceiling, make the deeper planes appear amazingly bright, as if materialized out of the air and bathed in a light opening on to vertiginous vistas. In particular, in the section *Saturn abducting Venus*, (*pls 26-7*), the baroque fantasy, and the use of light to create perspective, are amazing;

but it is the treatment of the sky especially which gives a clear sense of the extent to which Venetian art was able to transfigure the language of seventeenth-century painting, taking over its vitality and exuberance and expressing them in a new, eminently pictorial manner, in which the element of light has become central to the artist's feeling and mode of expression and is used to enhance and purify forms and colours.

The ceiling for the Scuola del Carmine was painted on canvas at about the same time as these Milanese frescoes. The sincerity and depth of feeling Tiepolo shows in these canvases does not lessen the splendour of the Christian heaven but gives it a deeper significance. Over the whole scene is the Virgin triumphant, carried by angels: the figures are emphasized by the light, which plays over the lower and higher planes so as to create, unaided, the ' aerial ' unity of the whole (*pls 24-5*).

In some of his works, however, Tiepolo indulged in an over-dramatic emphasis, as for example, in the *Road to Calvary*, in Sant'Alvise, Venice (1738-40), where he strove unduly after ' effect ' without the necessary basis of sincere feeling (*pl. 23*).

Celestial and profane Triumphs seem to be the subjects best adapted to Tiepolo's sentiment and approach at the time of his maturity: a good example is the *Miracle of the Holy House of Loreto*, painted in fresco on the ceiling of the Scalzi church, Venice (1743-5), a work unfortunately destroyed during the First World War. It is known to us through photographs and, even better, through the sketches – which Tiepolo often produced in large numbers before making his final choice – in London and Venice. The final work did not always correspond fully to the artist's original conception, and this is a case in point: in comparing the final version with the sketches, we observe that the space has been extended to form a large oval of sky over the entire nave, thus detracting from the harmony and unity of the composition: technical skill has taken the place of poetry, and bombast has replaced the original clarity of this complex theme.

The *Allegory of Strength and Wisdom* was painted for the

Palazzo Caiselli, Udine, and executed during the period now under discussion (1730-43). This work is remarkable for its effective colouring and the extraordinary transparency of the sky, where the artist's skilful technique has achieved an effect of translucent brilliance.

If in the canvases painted for Sant'Alvise, the *Road to Calvary*, there is to be seen, together with a certain over-emphasis, a recollection of Rembrandt, then this return to Rembrandt recurs in the *Agony in the Garden*, one of a series of religious paintings datable to 1745-50. Compared with the similar series painted earlier in Venice, it would seem that Tiepolo has here felt and expressed with greater sincerity a depth of religious emotion which the subjects suggested to him did not usually allow him. More perhaps than the central figures of the drama, the group to the right of the composition is given special prominence by a concentration of light and colour. Again the influence of Veronese is apparent in the forms and colours, but the background has become more up to date. These canvases represent an extraordinary parenthesis in the busy artistic career of Tiepolo, and once again he had to turn to large decorative compositions, of great effectiveness and refinement, such as those for the Palazzo Barbaro (now dispersed – in New York, Washington, Berlin, Copenhagen, etc.) and for Palazzo Cornaro (now in Florence), at which he worked intermittently between 1745 and 1750.

One of the few examples of Tiepolo's portraiture was produced at the beginning of this same period, and was painted in the same decorative manner: this manner was the more successful in that the subject of the portrait, Antonio Riccoboni (*pl. 36*), who had been dead for two hundred years, was not only to be reproduced, but extolled. This painting presents its subject with a wonderful immediacy, as he is placed in relief by the extraordinary light which falls upon the opaque background. This portrait was intended as a conscious act of homage, not only to a great man, but to the epoch in which he lived – the epoch Tiepolo thought of as the great period of portraiture. In the fine portrait of Procurator Querini (*pl. 42*), painted from life, the whole conception again obviously relates to

the Venice of the sixteenth century, and the architecture of the background is closely inspired by Veronese. In addition, we find in this portrait (but it should be noted that we are already speaking of a later period, perhaps about 1754) a much greater depth of psychological insight, together with a subtle vein of satire which later developed further in other paintings – self-portraits and commemorative works – which reveal the artist's gentle wit.

Tiepolo showed how far he was influenced by classical art when he painted a sequence of frescoes in Palazzo Labia, Venice, again with the assistance of Mengozzi-Colonna for the architectural perspective. On the ceiling of the main room he painted *Genius on Pegasus putting Time to Flight*; on the walls the *Meeting of Antony and Cleopatra* and the *Banquet of Cleopatra*. Several versions on canvas of these last two subjects are in the Arkhangelskoye Muzei, Moscow; the earliest is dated 1747. The style of this period, which Morassi (1955) describes as 'classicism' should rather be seen as a period of calm – of classic serenity. A further example is the allegory of *Neptune offering to Venice the riches of the sea* (*pls 40-1*) in the Ducal Palace, a classical work painted in the sixteenth-century tradition of courtly art.

Referring to the frescoes in Palazzo Labia, Pallucchini wrote (1960) that they still retain 'a fully baroque conception, revived by Tiepolo's decorative skill and inventive fantasy . . . Light, having broken up the dense sculptural masses of previous decades, imprints on form its own intense vibration'. Henceforth, in his finest works, Tiepolo remained a baroque artist, in the freest, happiest and most complete meaning of that term, pursuing an ever more personal and absolute conquest of light. This can be seen in the Neptune allegory in the Ducal Palace. This is a work of intense drama, with a depth of feeling comparatively rare in Tiepolo's art.

At about this period Tiepolo painted another work which, although basically faithful to the usual spirit of his art, departed from it in some respects. This was the *Consilium in Arena* (*pls 38-9*), painted to commemorate the occasion when the Council of the Order of Malta met in 1748 in

order to admit his patron Count Florio to its ranks. The unusual subject, and the pungent wit with which certain groups of figures are presented, make it seem likely that Giandomenico Tiepolo collaborated in the painting. It is, however, difficult to prove or disprove this, since at that time he modelled himself so closely on the style of his father that his contribution cannot be isolated with any certainty.

In 1750 the Tiepolo studio, which at this period was closely united in interpreting the wishes of the head of the family, was commissioned to work on the decoration of the Residenz at Würzburg. They began work on the ceiling of the Kaisersaal, with the assistance of the Venetian stuccoist Felice Bossi, and went on to paint two historical scenes on the walls (1752) and finally a large fresco on the ceiling of the grand staircase. The whole work was completed by about the autumn of 1735 (*pls 43-55*).

The subject of the frescoes in the Kaisersaal was the glorification of Frederick II Barbarossa, by whom the bishopric of Würzburg was established in 1168. The ceiling painting, *Apollo conducting Beatrice of Burgundy to Barbarossa* (*pls 43-5*) is a happy combination of classical allegory and historical reconstruction (note, however, the sixteenth-century background and costumes). Almost at the centre of the composition are the four horses of Apollo's chariot, emerging from artfully grouped clouds, and lit up by a blinding light, while the royal bride is seated in the chariot surrounded by superb *putti*. On the left, a figure of imperial majesty, Barbarossa awaits his bride on the high steps of his throne, attended by other magnificent allegorical figures.

The spectacular conception of this fresco includes fragments of sublime poetry (as in the nymph and river god waiting together beneath the staircase), alternating with episodes of a delightful atmospheric perspective, amazingly bold in their handling. But the most breathtaking thing of all is the admirably orchestrated range of colours which, more than the calculations of perspective, brings the vast composition into a unified entity.

The two wall paintings, *Investiture of Bishop Harold* (*pls*

46-7) and *Marriage of Barbarossa*, did not permit of the same freedom of expression, since Tiepolo was restricted by the theatrical surroundings of the room and also by the demands of historical reconstruction; but once again the spirit of Veronese was happily invoked. Completing the decoration of the room are the rococo stuccos of Bossi, which fit the scheme admirably. Among them Tiepolo painted patches of sky populated with pagan and Christian imagery, with pages, horsemen, knights and soldiers, some wearing classical costume, some dressed in Renaissance fashion. Some of these paintings were entrusted to assistants, especially Giandomenico, who is known to have painted the four overdoors.

Prince-Bishop Carl Philipp von Greiffenclau, who commissioned the decoration, was highly delighted with it, and asked Tiepolo to paint the ceiling of the grand staircase. The subject is *Olympus with the four quarters of the earth and allegories*, and the work covers the vast area of thirty metres by eighteen. Morassi has aptly described the variety of themes included in the composition around the central vision of Olympus as an ' iconographic encyclopaedia of the Age of Enlightenment '. Mounting the staircase from the lower floor, one sees first the human aspect of the triumph of Olympus: the portrait of Greiffenclau presides over the figure representing Europe, before whom the figures of the Sciences and Arts bow in homage (*pls 48-9, 51*). Some of the important personages of the court of Würzburg are present to pay homage to their prince, and among them appear the architect Balthasar Neumann, who was responsible for the palace (*pl. 51*), Tiepolo himself, his son Giandomenico, and the local artist who worked with him, Georg Anton Urlaub. On the remaining three sides of the ceiling are figures symbolizing the three continents known at the time apart from Europe: Africa (*pl. 50*), America (*pls 54-5*) and Asia (*pls 52-3*); they appear firmly anchored to the soil, in other words, to a system of architectural perspective.

The sharp differentiation between the crowded groups of figures round the sides of the ceiling and the celestial vision of Olympus in the centre (a differentiation which

23

appears to a much less noticeable extent in the sketch formerly in the Hendon Hall Hotel, London) was probably due to the unusually vast scope of the commission, but seems attenuated by a skilful use of light and colour, which Tiepolo has by now learned to wield as a magic instrument.

While Tiepolo was in Germany he did not, of course, confine his activity to the Residenz frescoes; besides the two altarpieces commissioned by the Prince-Bishop for the court chapel of the Residenz (*Fall of the rebel angels* and *Assumption*, 1752), he also painted works inspired by Tasso's romance *Gerusalemme Liberata* (*pls 56-8*), which were a preparation for his later work at the Villa Valmarana, near Vicenza, and for the other small canvases depicting the same subjects which are like wonderful pictorial 'impromptus'. The *Adoration of the Magi* altarpiece (*pl. 59*), executed for the Benedictine church of Schwarzach in 1753, is a typical example of Tiepolo's handling of a religious subject. The earthly figures are alive, invested with the warmth of human love, while the group formed by the Virgin and Child stands apart, as if rising up from among them, bathed in an ineffable, transfiguring light.

When he returned to Venice at the end of 1753, Tiepolo repeated the spiral perspective he had successfully employed in the Würzburg ceiling in his ceiling of the church of Santa Maria della Pietà; however, he was unable to find anything particularly new to express, and the work suffers from a certain mechanical lassitude.

The period immediately following Tiepolo's return from Germany should perhaps be considered as one of taking stock. Certainly, although it produced no dramatic achievements, there is no sign of flagging inspiration in any of the works he executed between 1753 and 1757, culminating in 1757 in the frescoes in the Villa Valmarana, at Monte Berico, Vicenza (*pls 60-5*).

Now that the correct chronology has been established (the date was long misread as 1737), and the part played by Giandomenico clarified, the relationship between this work and the later innovations in Tiepolo's style has become clear.

The subjects are taken from the *Iliad*, the *Aeneid*, *Orlando Furioso* and *Gerusalemme Liberata*. In the episode *Rinaldo abandoning Armida* (*pl. 61*), for example, the controlled handling of the background and scenic effects, the concentration on the essential characteristics of the figures, and a new clarity in the colour, focus the attention on the drama, so that the painter seems to share in the grandiloquent emotion engendered by the scene. Similarly, in the *Sacrifice of Iphigeneia* (*pls 64-5*), depicted in a highly theatrical manner through an architectural perspective which actually imitates a stage setting, the controlled handling of the characters, the undefined spatial expanses in the background and the suffused light, concur to produce a note of tender and deeply felt pathos, which becomes gently sensual in the wonderful scene of *Angelica with the wounded Medoro*.

Returning to large compositions, where now with superb mastery he created brilliant effects of perspective (the ceilings of the Ca' Rezzonico, Venice), Tiepolo painted in 1759 an altarpiece for the church of the Grazie at Este. The subject was *St Thecla imploring God to free a city from the plague*. In the upper part of the composition is the figure of the Eternal, descending from heaven surrounded by angels in answer to her prayer. In the lower part of the foreground there is a suggestion of the macabre. But in the bottom section of the painting, the landscape, studied from life, with the semi-human forms which populate it, and the contrast of light between the leaden sky and the livid appearance of the plague-ridden city, represent a new attitude, never before so clearly expressed in Tiepolo's art.

However, the painter of myths and triumphs was not long permitted to remain withdrawn in profound meditation. In 1761 he was commissioned to decorate the Palazzo Canossa, Verona (*Triumph of Hercules* on the ceiling of the ballroom, destroyed); in the same year, he began work at the Villa Pisani at Strà on the *Apotheosis of the Pisani family* (*pls 66-8*). Here, again, it will be helpful to bear in mind the artist's initial idea, which can be seen in the sketch in the Musée des Beaux-Arts, Angers. The sketch

has an intense effect of sunlight with extraordinary atmospheric effects; on the other hand, on the vast scale of the illusory perspective (arranged by Pietro Visconti, who was more restrained than the perspective artist Mengozzi-Colonna who had always worked with Tiepolo until a few years earlier), certain effects have been lost through being enlarged on such a vast scale.

However, there are some strikingly fresh passages, such as the lute player seen against the background of a dark pine forest, or the family portraits (Marina Pisani Sagredo with her deceased husband Andrea and young son Almorò).

We have now reached the early part of 1762, when Tiepolo was invited in the name of Charles III of Spain to go to Madrid to decorate the new royal palace; before he set off for Spain and while he was still engaged on the Strà paintings, he prepared a *modello* for the large ceiling of the Madrid throne room (now in the National Gallery, Washington).

As in the Villa Pisani, the theme for the Madrid decoration was to be a glorification, this time the *Apotheosis of Spain* (*pls 69-76*). It is immediately apparent that alongside the vortex type of composition which he used in the ceiling at Strà – the work on which he was still engaged when he planned the Madrid fresco – Tiepolo also drew upon the spatial organization which had proved so successful for the grand staircase of the Würzburg Residenz. The vast area to be covered (eleven by twenty-six metres) was surrounded by a continuous series of symbolic figures leaning upon the framework: over them the sky opens on to an infinite vista of space, peopled by other symbolic figures grouped around the central vision of the Empyrean with adoring angels. Unfortunately, once again the broad treatment of the perspective and the harmony of light and space envisaged in the original conception did not fully survive on the vast scale of the fresco, in which the extraordinary sun-drenched skies which create such an atmosphere of exultant aspiration in the *modello* have gathered large, violet storm-clouds.

However, the allegorical scenes painted on the throne-room ceiling include some of the liveliest and finest group

compositions ever executed by Tiepolo: see, for example, the group *Faith and other Christian Virtues*, or the superbly expressive *Neptune* group, or again, the dynamic representation of the *Spanish Provinces*.

Tiepolo painted another apotheosis after completing the great fresco for the throne room: this was the mythological allegory of Aeneas (1764), painted for the royal guardroom, the Cámara de los Alabarderos. Here again a comparison with the *modelli* (Boston, Museum of Fine Arts and Cambridge, Mass., Fogg Museum) is altogether to the advantage of the latter, even so far as the structure of the perspective is concerned. The final version shows greater rigidity in the figures and a duller light in the tones of the sky, as well as a more complicated treatment of perspective by means of 'receding tiers', while certain passages, such as the winged figure of Saturn and the Aeneas group, have lost all the liveliness and immediacy which they had in the *modelli* and degenerate into bombast.

The third fresco painted by Tiepolo for the royal palace was again an 'apotheosis', the *Triumph of the Spanish Monarchy* (in the Queen's antechamber, the Saleta de la Reina). Here again the perspective effect – although opening on to heavenly vistas – is firmly based on a succession of receding planes. When death came to interrupt Giambattista Tiepolo's vast and many-sided activity, it could be said of him that while he was aware of the new direction the world of art was taking, he deliberately remained apart and refused to adapt to it; instead he sought within himself new and more human values. His skies, which even when they had opened on to Christian Triumphs, had expressed an exuberance that was purely pagan in spirit, had submissively bent towards the earth where they discovered themes for another type of poetry.

I think therefore that one can agree with the view recently expressed by Pallucchini: 'We must . . . look for the real Tiepolo in his moments of greatest and most immediate abandon, when that vein, sombre and troubled in his youth, impassioned and serene in his maturity, and gently melancholy in his last years, flows freely, without becoming melodramatic recitative and decorative virtuosity.'

Tiepolo and the Critics

Giambattista Tiepolo cannot be described as an artist who was misunderstood or neglected in his own lifetime. Indeed, the Venetian Republic, of which he was a citizen, showered honours upon him and not only recognized his stature and originality as an artist, but also found in his art some consolation during the years of its decline. But Tiepolo's success was not limited to the narrow sphere of Venice, or even to Italy. All over Europe, he was considered the most complete representative of a taste in painting which had ceased to be Venetian and had become European: this is seen from the fact that he was asked to produce paintings for Germany, Sweden, Spain and even Russia, where he sent works of art straight from Spain during his far from easy stay in that country. His principal merit, in the words of Morassi, was that ' from the very beginning, Tiepolo embodied in himself all the current artistic ideals of the age, and at the same time, he revived Venetian painting, giving it substance, naturalness and light'. This explains the fame which accompanied him from the time of his earliest commissions.

Among his contemporaries, who in one way or another could be called connoisseurs, the favourable criticism of Count Algarotti should be noted; among those who came after him, when neoclassical art was to the taste of the time, he had numerous declared admirers (of whom Goethe was one). This suggests that the difficulties of Tiepolo's last years in Spain were due not so much to the artistic rivalry of the neoclassical group, personified by Mengs, as to personal intrigues in the surroundings of the court. However, the growing predominance of the neoclassical school, based on the theories of Winckelmann, was to gain a temporary victory over Tiepolo, just as it was to cast a shadow over the whole art of the baroque. At a distance of about a hundred years, painters like Delacroix began to realize the value of Tiepolo's art, and this revaluation was continued by the Impressionists, who saw

in Tiepolo a forerunner of their fundamental principle of *plein air* painting; finally, it was upheld, as part of the revaluation of baroque art in general (Riegel and Dvořák) which followed in the early years of this century.

One of the first monographs on Tiepolo was by F. H. Meissner (*Tiepolo*, Bielefeld 1897); it was followed by others by H. de Chennevières, (*Les Tiepolo*, Paris 1897), H. Modern (*G. B. Tiepolo, eine Studie*, Vienna 1902), P. Molmenti (*G. B. Tiepolo, la sua vita e le sue opere*, Milan 1909) and E. Sack (*G. B. und Domenico Tiepolo*, Hamburg 1910). The writings of Sack and Molmenti are still reliable sources.

The works of Giambattista Tiepolo were later examined from two points of view, and both are important for the purpose of arriving at a true understanding of the nature of his art. The first method was to study his origins, that is, his early activity; the second was to concentrate on the distinction between his own work and that of Giandomenico. In the former category the first contribution was made by H. Voss ('Über Tiepolos Jugendentwicklung', *Kunst und Künstler*, 1922), followed by G. Fogolari ('Dipinti giovanili di G. B. Tiepolo', *Bollettino d'Arte*, 1923), and the most valuable studies are by A. Morassi ('The Young Tiepolo', *The Burlington Magazine*, 1934; 'More about the Young Tiepolo', *ibid.*, 1935; 'An unknown early work by Giambattista Tiepolo', *ibid.*, 1937; 'Yet more about the young Tiepolo', *ibid.*, 1948; 'Novità e precisazioni sul Tiepolo', *Le Arti*, 1941; 'Opere giovani del Tiepolo', *L'Arte*, 1944).

Morassi was responsible also for extending his research to include the second field of study, drawing a distinction between the artistic personalities of Giambattista and Giandomenico Tiepolo ('Domenico Tiepolo', *Emporium*, 1941), while G. Fiocco had already written on Lorenzo ('Lorenzo Tiepolo', *Bollettino d'Arte*, 1925).

For modern monographs, see: G. Fiocco, *G. B. Tiepolo*, Florence 1921; T. Pignatti, *Tiepolo*, Florence 1951; G. Vigni, *Tiepolo*, Florence 1951; A. Morassi, *G. B. Tiepolo*, London 1955. These were preceded, accompanied, or followed by numerous studies of individual works or groups

of works: among others, mention should be made of the work of P. D'Ancona on the Palazzo Clerici frescoes (1956), R. Pallucchini (1945) and A. Morassi (1940 and 1946) on the Villa Valmarana frescoes; G. Giocco (1942), J. Fernández (1943) and J. Sánchez Cantón (1953) on the Spanish period; Freeden-Lamb (1956) on the Würzburg frescoes. Account should also be taken of the catalogue for the Tiepolo exhibition (G. Lorenzetti, *Mostra del Tiepolo*, in collaboration with G. Mariacher, Venice 1951) and the chapters on Tiepolo by G. Fiocco in the *Enciclopedia Italiana* (1937) and by A. Morassi in the McGraw-Hill *Encyclopedia of World Art* (1965); or the chapter on Tiepolo in R. Pallucchini's brilliant and learned *Pittura veneziana del Settecento* (Venice and Rome 1960).

The most useful single work, A. Morassi's *A Complete Catalogue of the Paintings of G. B. Tiepolo*, London 1962, contains a detailed catalogue of the works accompanied by a complete Tiepolo bibliography.

Notes on the Plates

1 Glory of St Teresa, c. 1720-25. Fresco. Detail. Venice, Chiesa degli Scalzi, ceiling of the Ruzzini Chapel. Dating given according to Morassi (1962); R. Pallucchini (1960) is substantially of the same opinion. The most accredited sources ascribe it to Tiepolo's hand, apart from the *quadratura* (see p. 5), which is the work of Mengozzi-Colonna. On the basis of a comparison of this work with the *Glory of St Dominic* by G. B. Piazzetta at San Zanipolo, A. Morassi (in *Arte Veneta*, 1949) entered into an interesting and still unresolved discussion as to whether Tiepolo's dependence on Piazzetta is too much taken for granted. Pallucchini (1960) took up the question and suggested that a probable answer is that both artists began work simultaneously on these similar subjects, but Tiepolo completed his task more rapidly and so passed from the rank of pupil to that of competitor.

2-8 Biblical stories, c. 1725-27. Frescoes. Udine, Palazzo Dolfin (Palazzo Arcivescovile), gallery. According to Morassi (1962), painted about 1725; according to Rizzi (1966), 1727. On the main wall (against the windows) are: *Three Angels Appearing to Abraham* (Genesis xviii), *Rachel Hiding the Idols* (Genesis xxi) and *Angel appearing to Sara* (Genesis xviii). The principal wall and opposite side contain monochrome figures resembling bronze statues. They represent prophetesses mentioned in the Old and New Testaments. On the sides of the central fresco on the non-window wall are two monochrome paintings: *The Meeting of Jacob and Esau* and *Jacob wrestling with the Angel*. On the ceiling is the *Sacrifice of Abraham* (Genesis xxii) in the centre; with the *Angel comforting Hagar* (Genesis xxvii) on the sides. This complex work, even more than the *Fall of the Rebel Angels* which he painted at the same time for the Grand Staircase of the same Archbishop's Palace, is one of Tiepolo's early masterpieces. Mengozzi-Colonna was responsible for the architectural perspective.

9-11 The Judgment of Solomon, c. 1727-28. Fresco, 655 × 360 cm. Details. Udine, Palazzo Dolfin, Sala Rossa, ceiling. The fresco is completed by four angular medallions depicting prophets. This is perhaps the first of Tiepolo's historical compositions to be executed in perspective on a ceiling, and the low height of the room increased the difficulty of creating an illusion of depth. In this work Tiepolo can be seen to have come closer to the world of Veronese (in the types of the figures and in the colour tones); in the gallery paintings (especially the *Angel appearing to Sara, pl. 8*) this world is triumphant.

12 Temptations of St Antony, c. 1725-28. Canvas, 47 × 40 cm. Milan, Pinacoteca di Brera. According to Morassi (1962) this work

is closely connected with the *Venus at her Mirror* in the Gerli Collection, and was painted at the time of Tiepolo's first historically verified visit to Udine, the period of the frescoes for the Palazzo Dolfin. The painting came into the Brera in 1929. The small dimensions and intensity of feeling place this painting among Tiepolo's most penetrating works of fantasy and invention; with its depth of psychological insight, this work is probably more acceptable to the modern taste than the vast fresco compositions on which Tiepolo worked during the same period.

13 Resurrection, after 1730 (?). Oil on canvas, 45×90 cm. Udine, Cathedral. According to Morassi (1962), this canvas is stylistically related to the frescoes painted for the Chapel of the Holy Sacrament (and is therefore to be dated 1726). Pallucchini (1966, introductory essay to the ' Mostra della pittura veneta del Settecento in Friuli ') wrote that it probably belonged to the latter part of the 1740s, and at all events to a later period than these frescoes. Rizzi (1966) believes it to be contemporary with the frescoes in the Chapel of the Holy Sacrament of Udine Cathedral, where it is hung, ' or, more probably, slightly later (about 1730) '. The composition and clear colour tones would seem to indicate a date later than 1730.

14 Abraham visited by the Angels, c. 1732. Oil on canvas, 120× ×140 cm. See note to *pl. 15*.

15 Hagar and Ishmael, c. 1732. Oil on canvas, 120×140 cm. Venice, Scuola di San Rocco. Morassi (1962) suggests the date 1732 for these two paintings. At this date Tiepolo had completed the decorations for the Palazzo Dolfin in Udine (where it is possible to recognize the vigorous brushstrokes associated with Pellegrini) and the Palazzo Casati, later known as Dugnani, in Milan (where he returned to the manner of Veronese in the composition and colour-tones) and seemed to wish to return to his original sources of inspiration, through a reappraisal of Piazzetta's treatment of light and colour. It is apparent that this return to the inspiration of his early years, and the spiritual intensity which emerged through a more emphatic use of chiaroscuro, were superseded by Tiepolo's passion for a more intricate play of jewel-like effects of colour. This makes of these two paintings works of deeply felt lyricism, in which the emotion inherent in the subjects is intensified through a rich orchestration of colour.

16 Education of the Virgin, 1732. Canvas, 200×362 cm. Detail. Venice, Church of Santa Maria della Fava. Dated, and mentioned by Zanetti (1733) as an altarpiece painted for this church, where it can still be seen today. Morassi (1955) includes this painting among those which he describes as ' in a certain sense less advanced ' than the frescoes already painted in Milan. In fact, it is possible to see here what could be described as a point of crisis in Tiepolo's

career, when he was hesitating between the conquest of light which he had already achieved and a return to a deeper emotional content, in the manner of Piazzetta. But in spite of the somewhat massive monumentality of the composition, it seems clear that Tiepolo had now chosen the path of light, and this was to be confirmed by the paintings he executed at Bergamo.

17 St Roch. Canvas, 42.5×54 cm. Udine, Castello di Zoppola. Rediscovered by Rizzi, 1966. Part of the St Roch series to which Morassi drew attention in 1962. Tiepolo painted several versions of this particular subject, and this may be due to the fact that he was probably made a member of the Venetian Scuola, or Brotherhood, dedicated to St Roch. The work reproduced is dated 1732-33 and the colouring reflects a particularly tender mood, a mood from which any note of harshness is absent. The whole colour composition is orchestrated in delicate tones, with brighter touches of blue, red and yellow providing a happy counterpoint.

18 The Holy Family with St Cajetan (Gaetan), 1735-40. Oil on canvas, 73×129 cm. Venice, Accademia. Morassi (1962) dates this painting 1735-40. It was painted for the private chapel of the Palazzo Labia and purchased for the Accademia in 1887. This is one of Tiepolo's most interesting religious works; in it he completely frees himself from the formal rules of the iconographic tradition. It is a vision bathed in sunlight, which falls strongly on the central action, leaving the bystanders in the shadow. The influence of Veronese is apparent in the choice of a white architectural background and the heavenly expanses opening out on to infinite vistas.

19-20 St Dominic instituting the Rosary, 1737-39. Fresco. Venice, Gesuati, ceiling. Other sections of this ceiling painted by Tiepolo's hand are *The Virgin and St Dominic* and the *Glory of St Dominic* (see pp. 34, 35). The surrounding stuccos and monochrome paintings are the work of assistants (according to G. M. Pilo the work of Francesco Zugno, *Paragone,* March 1959). Preparatory sketches are to be found in the Crespi collection, Milan, and in Berlin. From the point of view of iconographic interpretation, this is one of the most complex religious subjects Tiepolo ever undertook (the symbolism has now been fully clarified). The exciting aerial perspective is based on a succession of planes and architectural structures with pyramidal projection, over which looms the sky, which seems about to hurtle down over the viewer. This composition, reduced to a modest provincial style, was recalled by Valentino Rovisi of Modena, a pupil of Tiepolo's from the Trentino, when he painted a similar subject in the Chapel of the Rosary, Modena.

21-22 The Holy Trinity, 1738 (?). Oil on canvas, 160×320 cm. Udine, Cathedral. Paid for in 1738 by Cardinal Daniele Dolfin. Rizzi (1966) writes that in this painting Tiepolo employs ' a turgid, sensual, chromatic impasto, through which golden shafts glow, as in the last works of Titian, or in Rembrandt.'

23 Road to Calvary, c. 1738-40. Detail. Canvas, 517×450 cm. Venice, Church of St Alvise. Mentioned in 1740 by Albrizzi (*Il forestiere illuminato...*, Venice). A sketch exists in Berlin. This painting forms part of a triptych, comprising also the *Flagellation* and *Crowning with Thorns.* According to Pallucchini (1960) this is an unsuccessful attempt at a dramatic tone which Tiepolo never repeated; Morassi (1953), on the other hand, considers it a masterpiece.

24-25 Madonna del Carmelo (Our Lady of Carmel with St Simon Stock), 1739. Canvas, 342×533 cm. Venice, Scuola del Carmine, Sala Grande. Placed in its present position in 1743. With other paintings it was hung in the Scuola del Carmine in 1739.

26-31 Ceiling, depicting mythological subjects, c. 1738-40. Fresco, 2200×540 cm. Milan, Palazzo Clerici. Details. A sketch for this fresco is in the Hausmann collection, Zurich. This is one of the most phantasmagorical Olympic creations of Tiepolo. It was highly praised by his contemporaries. some of whom even dedicated poems to it. The first section shown (*pls 26-27*) represents *Saturn abducting Venus.*

32 Miracle of the Holy House of Loreto, c. 1743. Canvas, 85×124 cm. Venice, Accademia. Sketch for the fresco on the main

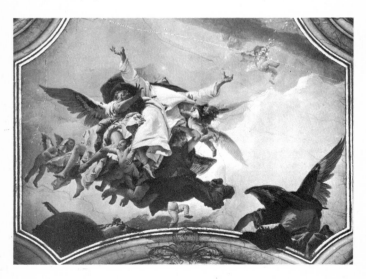

The Glory of St Dominic, 1737-39 (see p. 33)

ceiling of the Carmelitani Scalzi Church. This canvas is far inferior to the sketch in the Rosebery collection, London, where 'form, colour and light seem to be one' (Pallucchini, 1960).

33 Time revealing truth, 1743. Canvas, 340×254 cm. Vicenza, Museo Civico. Detail. Painted for the ceiling of the Villa Cordellina at Montecchio Maggiore, then taken to the Palazzo Cordellina, Vicenza. Since 1935 it has been on exhibition in Vicenza.

34-35 Meekness and Humility, 1744. Canvas, 240×235 cm. Venice, Scuola del Carmine. Part of the ceiling decoration for the main room of the Scuola. The decoration was completed by three sections with symbolic figures representing the Virtues, and four side scenes with figures of angels.

36 Portrait of Antonio Riccoboni, c. 1745. Canvas, 90×120 cm. Rovigo, Accademia dei Concordi. This is an idealized commemorative portrait of a famous citizen of Rovigo who lived two centuries earlier.

37 St Proculus as bishop meets St Fermus and St Rusticus, c. 1740-45. Canvas, 32×57 cm. Bergamo, Accademia Carrara. This work is usually, and incorrectly, known as *St Maximus and St Oswald*. Owing to certain similarities, it was supposed to be a first version of the altarpiece in the church of Santi Massimo ed Osvaldo

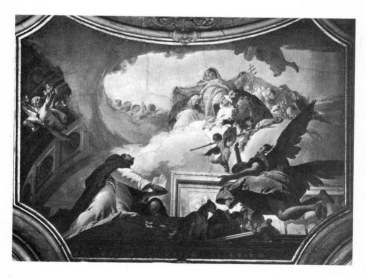

The Virgin and St Dominic, 1737-39 (see p. 33)

in Padua (*c.* 1742), but Morassi (1966) more correctly places it as one of a series of sketches and *modelli* representing Saints Proculus, Fermus and Rusticus, in London and New York, and saw as a model for the Padua altarpiece the more obviously similar sketch now in Zurich (Ruzička collection). In my opinion, the small canvas in the Pushkin Museum, Moscow, might be a preparatory model either for the Padua altarpiece or, like the present canvas, for some other work.

38-39 Consilium in Arena, 1749-50. Canvas, 194 × 124 cm. Udine, Museo Civico. Reference has been made in the text to the historic occasion commemorated by this painting, which depicts the meeting of the Council of the Knights of Malta to elect Count Filippo Florio, of Udine, to the Order. The Count had previously been denied entry, but was admitted on this occasion after Count Antonio di Montegnacco pleaded his case before the Council. The painting, as art historians are agreed, was executed by Giambattista with considerable help from Giandomenico. To Giandomenico is to be ascribed the element of humour in the portraits of the numerous characters, with a ' dispersal ' of interest that only the organization of the pictorial conception, created by his father, could restore to unity.

40-41 Neptune offering to Venice the riches of the sea, 1745-50. Canvas, 175 × 112 cm. Venice, Ducal Palace. A richly orchestrated painting, this is one of the most deeply felt of Tiepolo's commemorative works.

42 Portrait of Procurator Giovanni Querini, c. 1749 or c. 1754. Canvas, 158 × 235 cm. Venice, Pinacoteca Querini Stampalia. According to Morassi (1962), this work should be dated about 1749, while others (Pallucchini, 1960) place it after the journey to Würzburg. Apart from the uncertainty over the date, there is also confusion over the identity of the sitter and of the artist. It was long believed that this was one of Giandomenico's paintings, but Michael Levey (1961) has questioned this belief. Of the few portraits painted by Tiepolo, this is one of the warmest and most sincere examples.

43-45 Apollo conducting Beatrice of Burgundy to Barbarossa, 1750-51. Fresco. Würzburg, Residenz, ceiling of Kaisersaal. See note to *pls 46-47.*

46-47 Investiture of Bishop Harold, 1752. Würzburg, Residenz, wall of Kaisersaal. The figure of Bishop Harold is a portrait of Prince-Bishop Carl Philipp von Greiffenclau. As Morassi wrote (1962), ' the Würzburg period marks one of the highest creative moments of Tiepolo's activity ', when he was intent on the conquest of aerial space and brilliant luminosity.

48-49, 51 Europe, 1753. Fresco. Würzburg, Residenz, ceiling of staircase. Detail. The cartouche contains a portrait of Prince-Bishop

von Greiffenclau. Among the representatives of the sciences and arts is the architect of the Residenz, Balthasar Neumann (in military uniform, *pl. 51*).

50 Africa, 1753. Fresco. Würzburg, Residenz, ceiling of staircase. Detail. See note to *pls. 54-55.*

51 See pls 48-49.

52-53 Asia, 1753. Fresco. Würzburg. Residenz, ceiling of staircase. Detail. See note to *pls 54-55.*

54-55 America, 1753. Fresco. Würzburg, Residenz, ceiling of stair-case. The allegories of *The Four Quarters of the Earth* (*pls 48-55*) form an intermediate ' earthbound ' plane round the cornice of the ceiling. In the centre soars a vision of Olympus (not illustrated).

56-57 Rinaldo in the Garden of Armida, 1751-53. Canvas, 104×143 cm. Munich, Alte Pinakothek (taken from the gallery of the Würzburg Residenz). Signed. One of the secular paintings executed during the years 1751-53, at a time when Tiepolo was commissioned mostly to produce religious works. The subject is taken from Canto XVI of Tasso's *Gerusalemme Liberata.*

58 Rinaldo abandoning Armida, 1751-53. Canvas, 105×142 cm. Munich, Alte Pinakothek. Signed. See note to *pls 56-57.*

59 Adoration of the Magi, 1753. Canvas, 211×425 cm. Munich, Alte Pinakothek. Signed and dated 1753. Painted during the Würzburg period for the Benedictine church of Schwarzach. This is one of Tiepolo's masterpieces of this period, with its sun-drenched composition sustained almost entirely by light.

60-65 Episodes from the Iliad, the Aeneid, the Gerusalemme Liberata and the Orlando Furioso, 1757. Frescoes. Vicenza, Villa Valmarana. Details. In the Palazzina. the villa proper, Giambattista Tiepolo painted the ceilings and walls of four rooms, one for each of the four epic poems which formed his theme. In the so-called Foresteria, the guest wing of the villa, he painted the Sala dell' Olimpo with Giandomenico's assistance, while the rest of the building was decorated, in a realistic, satirical vein, by Giandomenico alone. Tiepolo's preference here for lyrical rather than epic subjects reflects a moment of crisis in the development of his art, an apparent reaction against the vast sweep of the Würzburg compositions. Morassi (1962) explains this as being due to his contact with contemporary painting of the French rococo and South German schools, and says it remained an isolated facet of Tiepolo's artistic development. The work of Giambattista and Giandomenico in the Villa Valmarana is also of considerable importance for an insight into the different temperaments of the two artists.

66-68 Apotheosis of the Pisani Family, 1761-62. Fresco, 1350×
2350 cm. Strà, Villa Pisani. Ceiling of the ballroom. Executed
at the end of 1761 and in the first months of 1762. There is a
sketch in the Musée d'Angers. Tiepolo, now a fully mature artist,
seems to wish to affirm in this new vista of expanses of skies that
he has come through the crisis in his art to which the Villa Valma-
rana frescoes bear witness, but certain lyrical passages (such as the
group of lute players in a pine forest, at the bottom left) indicate
that the more intimate poetic mood of those frescoes had not been
lost, even though it had to be incorporated into the commemorative
art of an apotheosis (see illustration opposite).

69-76 Apotheosis of Spain, 1764. Fresco. Madrid, Palacio de
Oriente, ceiling of Throne·Room. This is the last great fresco
undertaking of Giambattista Tiepolo, who signed it in 1764. Several
sketches for this immense work are in existence. It was planned
while Tiepolo was working at Strà, and was intended to extol the
glory of Spain through acts of homage rendered by allegorical figures
symbolizing the Virtues, the quarters of the Globe, the conquered
lands, and the Olympian gods, arranged in a phantasmagorical com-
position in which Tiepolo has taken account of the experience gained
at Würzburg and Strà. The groups of figures are spread throughout
the vast sky, which no longer has the bright splendour of the Würz-
burg skies, and although in their relative isolation these groups can
be appreciated individually, yet this dispersal makes it difficult to per-
ceive the composition as a unified whole.

77 Olympus, 1762-70. Canvas. 62×86 cm. Madrid, Prado. Paint-
ed as a *modello* for a ceiling, to be sent to the imperial court of
Russia. Since not all the Olympian gods are present and Venus is
in the place of honour, it is certain that this painting represents
a Triumph of Venus. Even on the reduced scale of a sketch,
it is possible to visualize the expanses of space typical of Tiepolo's style
when he was working on the ceiling of the Madrid throne room.

78 St Francis of Assisi receiving the Stigmata, c. 1767. Canvas,
153×278 cm. Madrid, Prado. Signed. Executed for the church of
Aranjuez, this is one of the most moving of Tiepolo's religious
paintings; in it he appears to have recovered the depth of emotion
present in the early paintings of St Roch. All extraneous emphasis
has been discarded, and the striving for what is essential indicates
a more penetrating grasp of psychological values.

79 The Angel of the Eucharist, c. 1769-70. Canvas, 178×185 cm.
Madrid, Prado. Painted for the church of Aranjuez about 1769-70.
This is a fragment of the altarpiece of *St Paschal Baylon adoring
the Holy Sacrament*, which was replaced by a painting by Mengs and
later dispersed and mutilated. In the serene image of the angel and
the exultant cherubs may perhaps be found the final message of the
art of Giambattista Tiepolo.

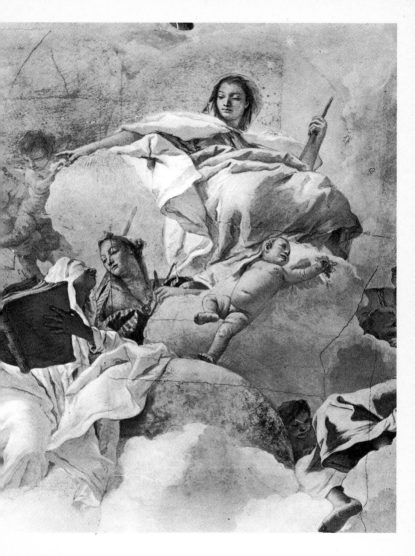

Allegorical figure, detail of pl. 66, Apotheosis of the Pisani Family, 1761-62
(See note on facing page)

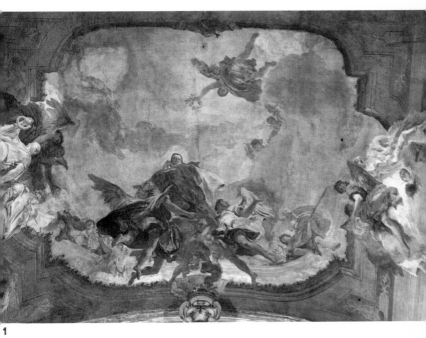

1

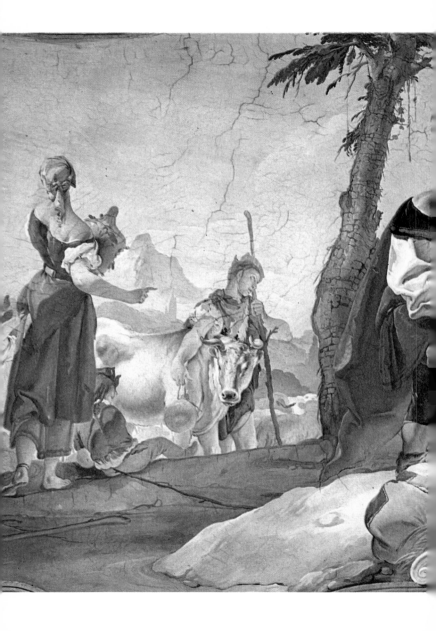

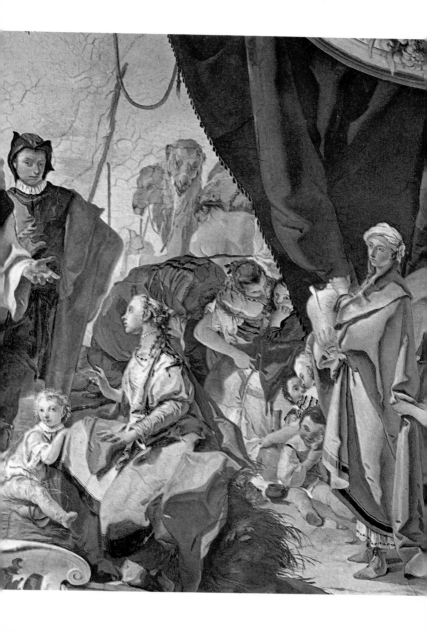

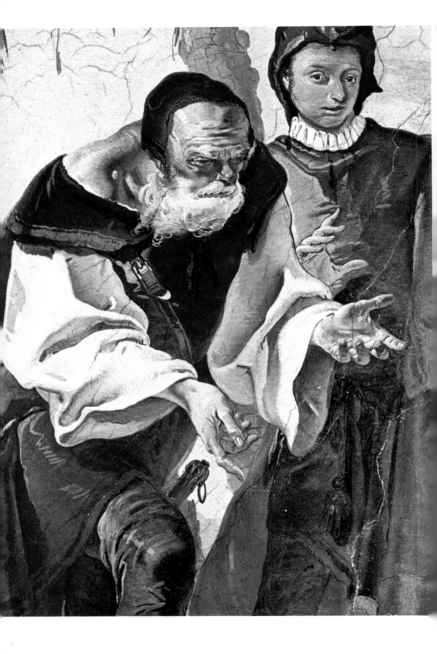

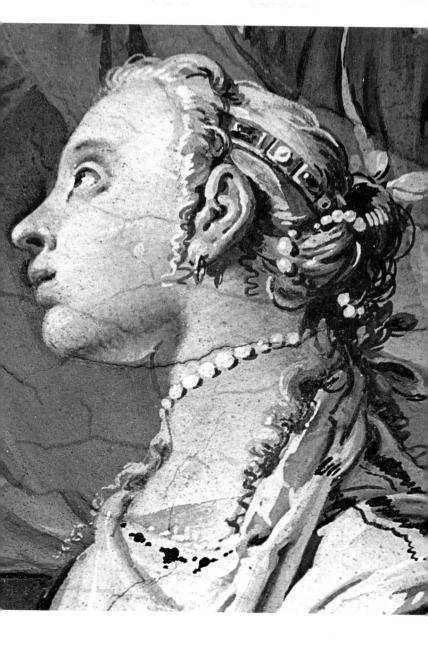

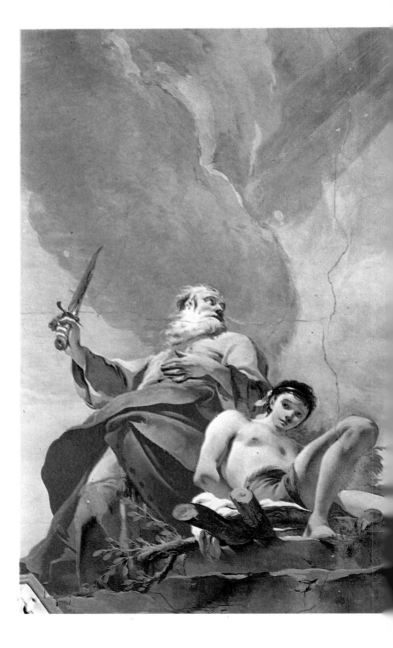

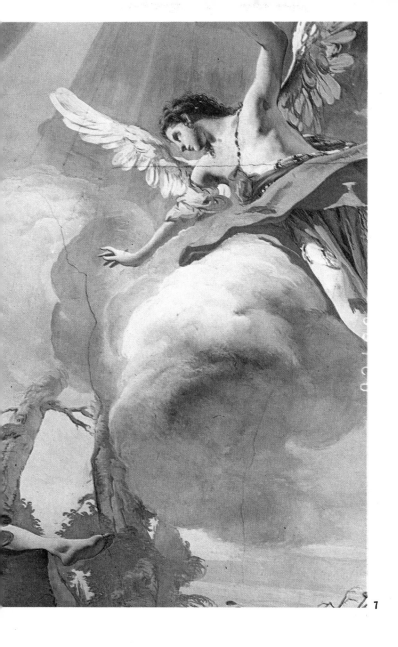

1

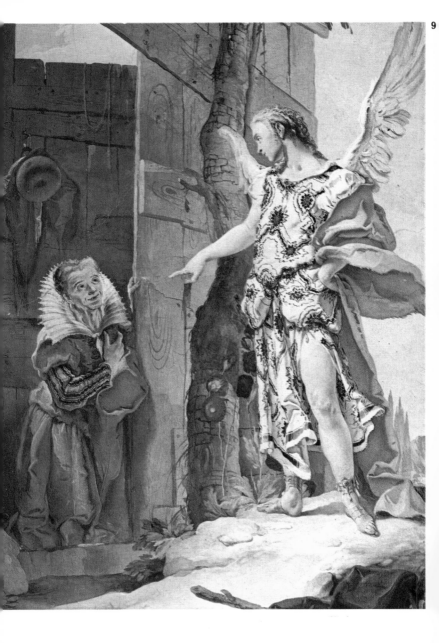

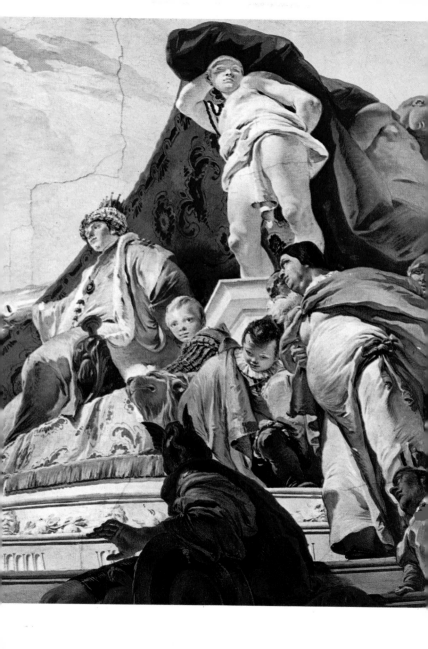

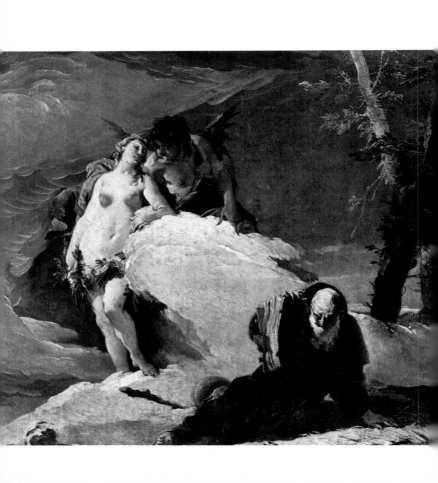

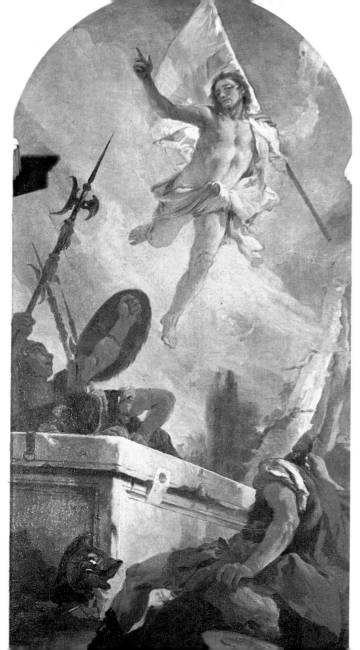

←12

13

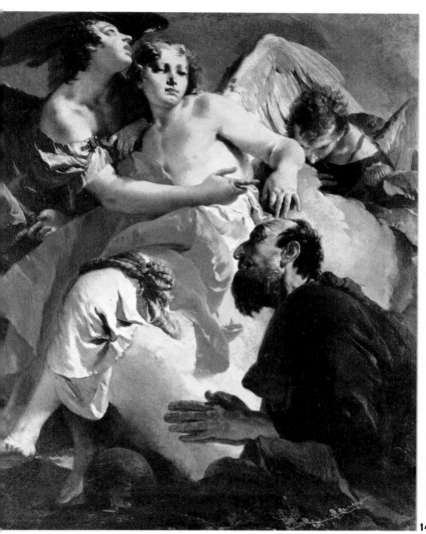

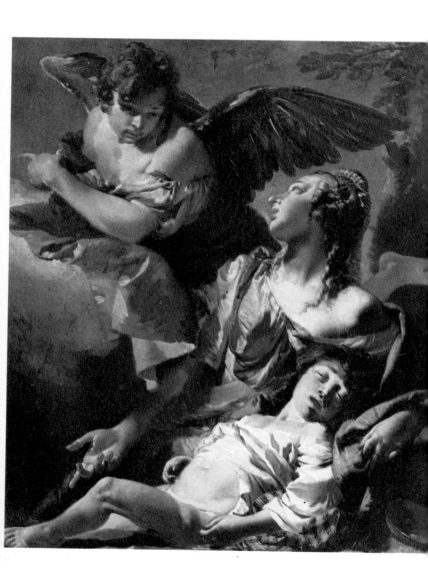

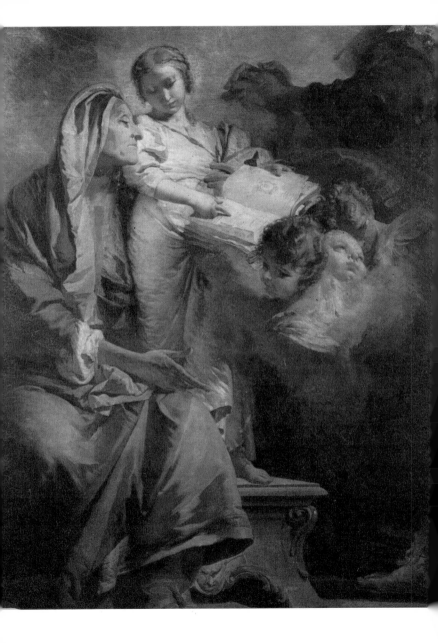

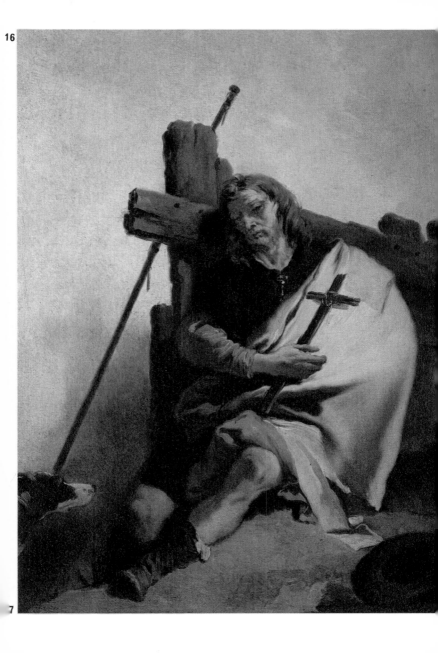

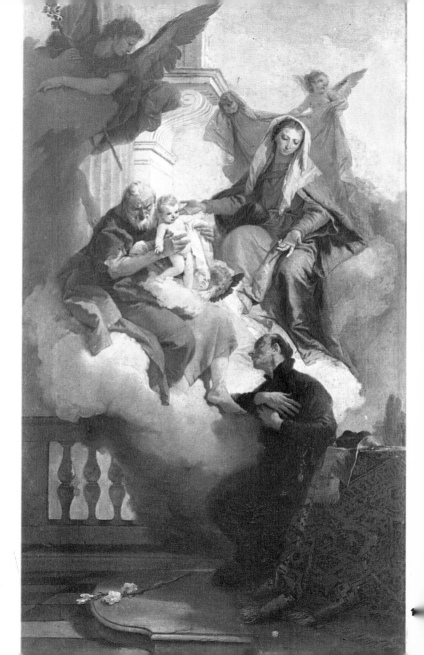

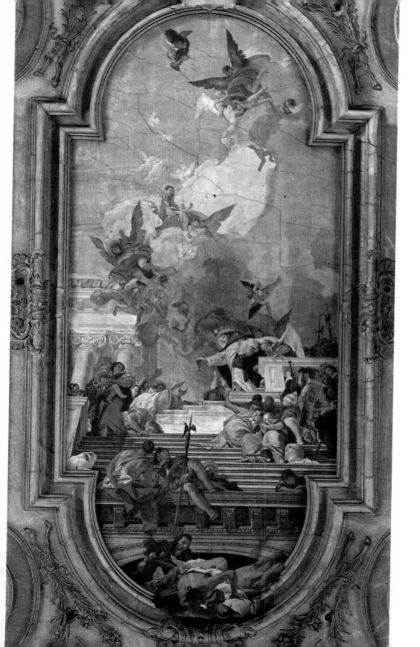

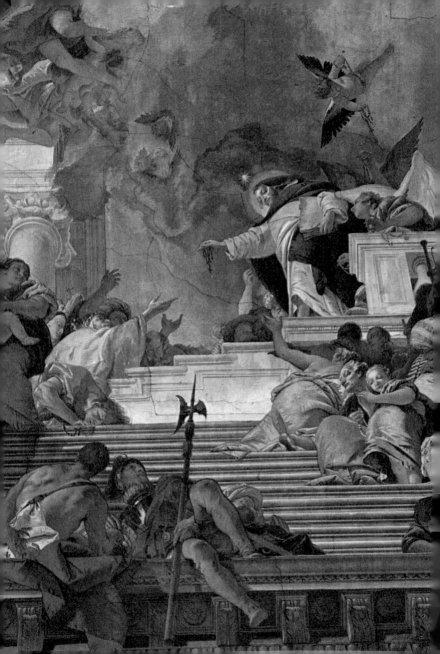

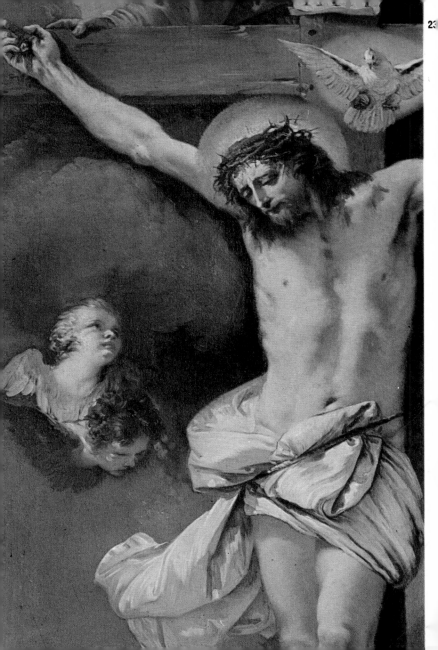

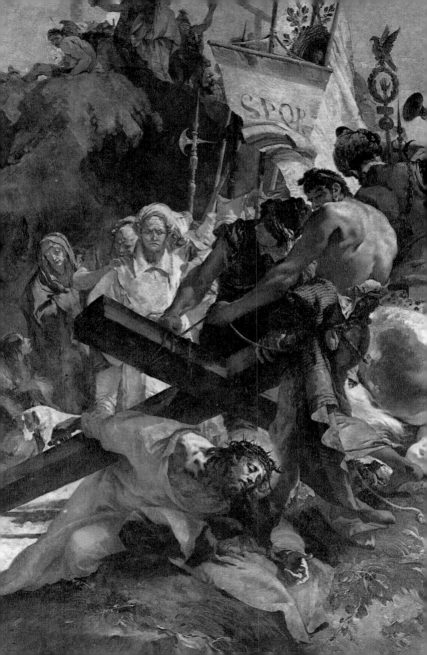

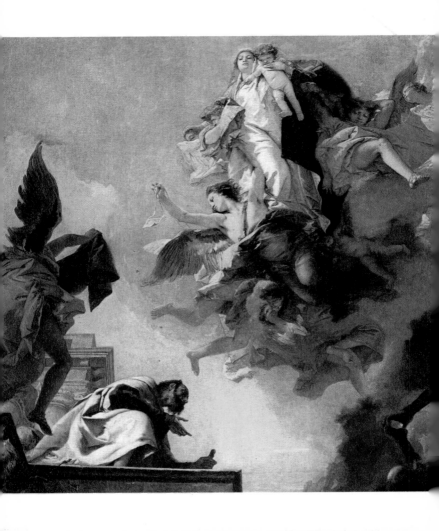

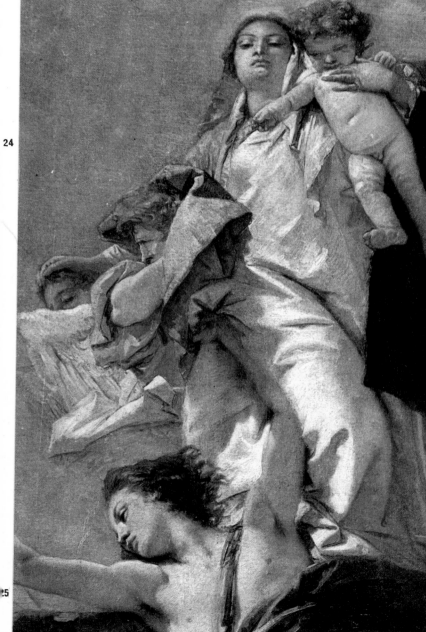

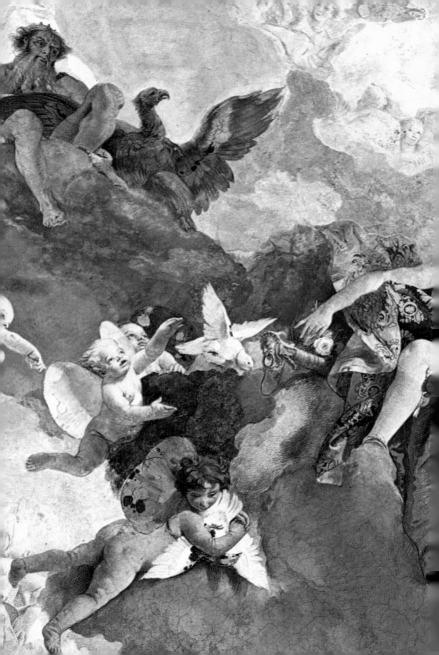

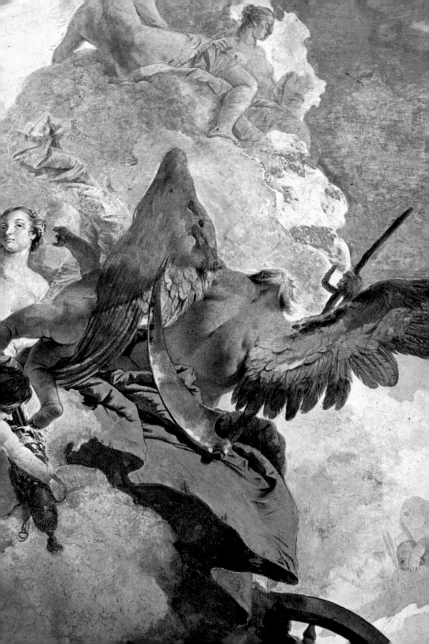

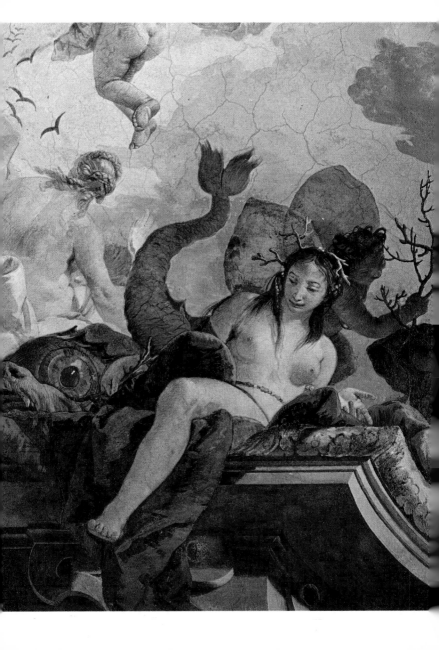

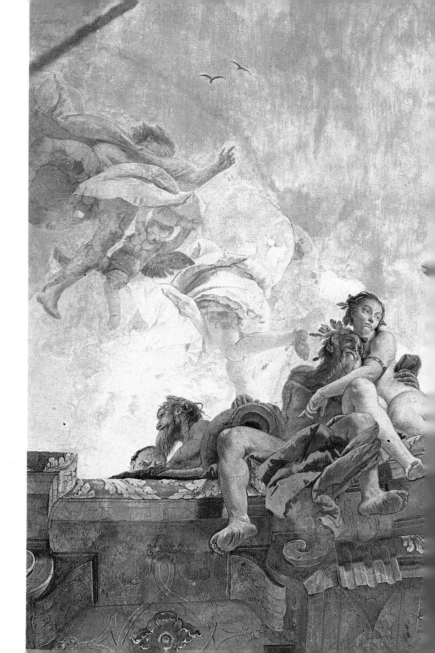

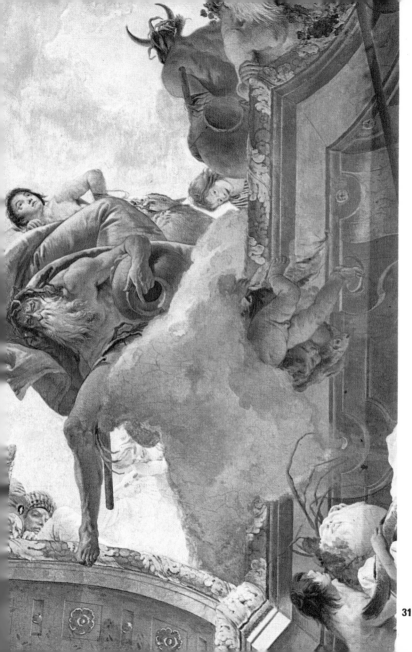

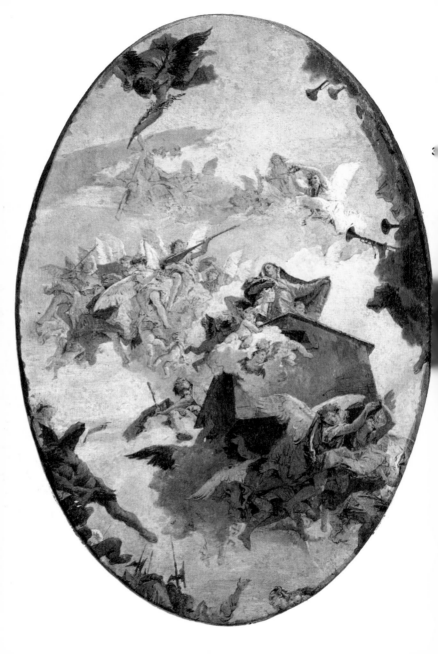

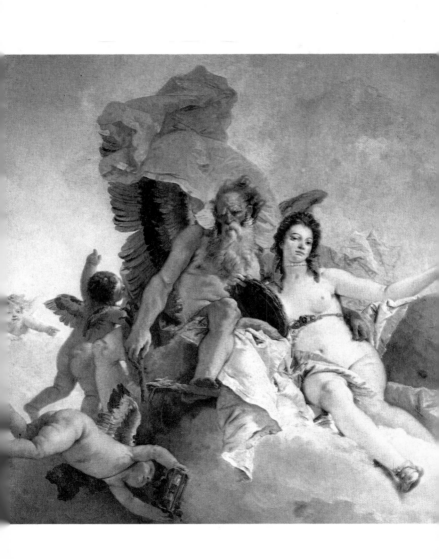

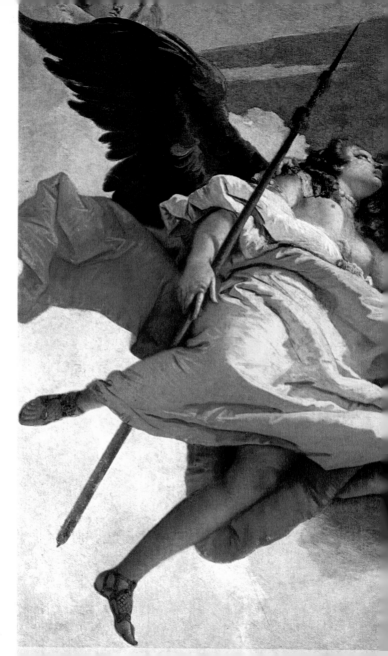

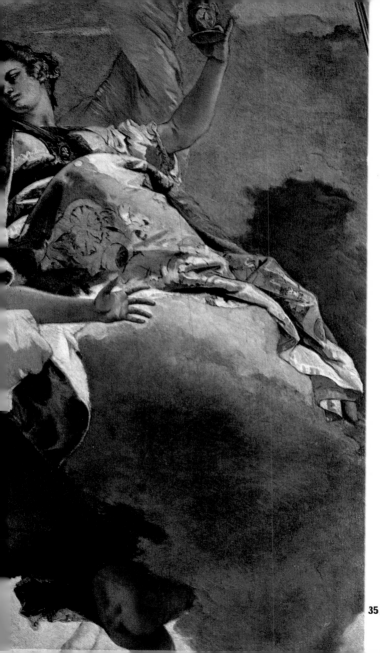

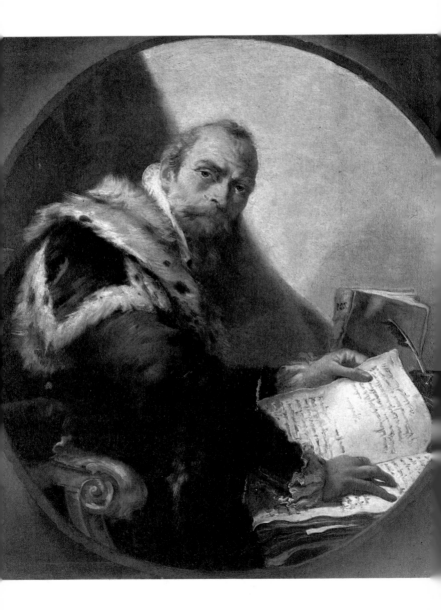

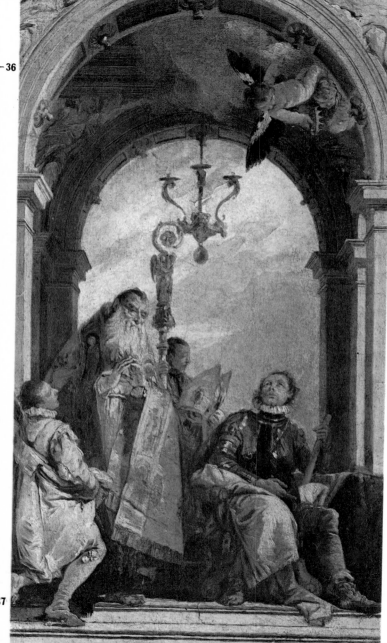

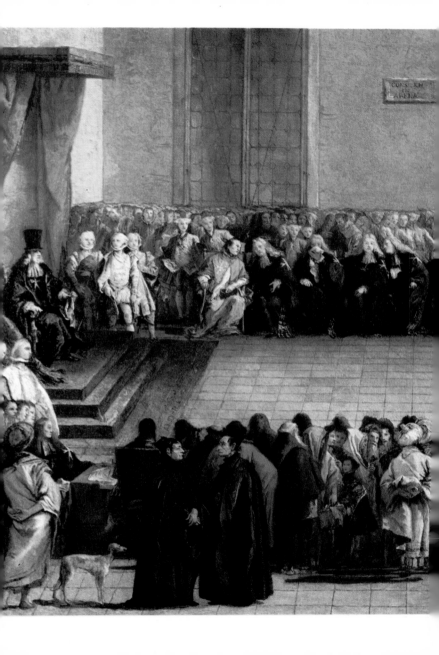

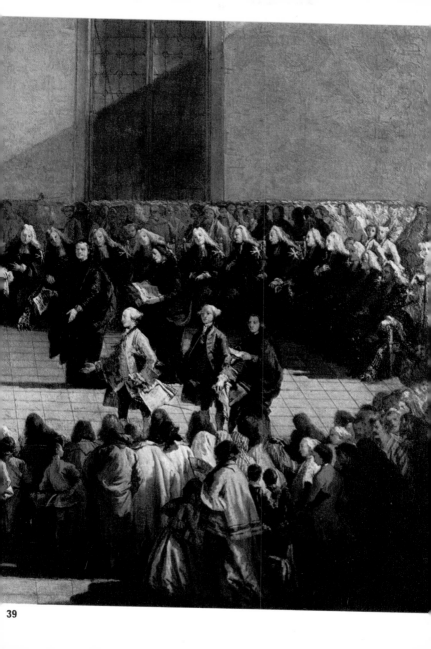

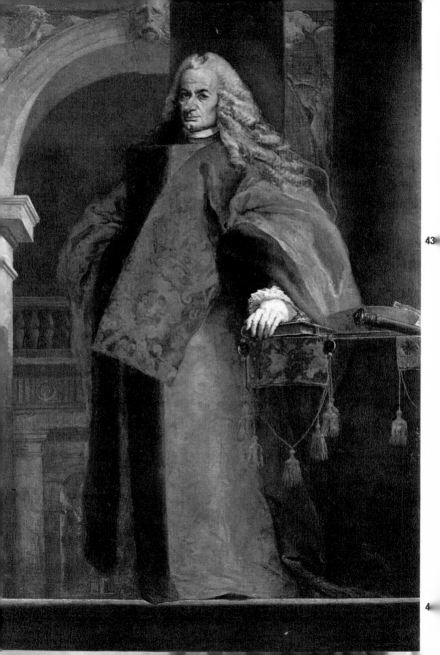

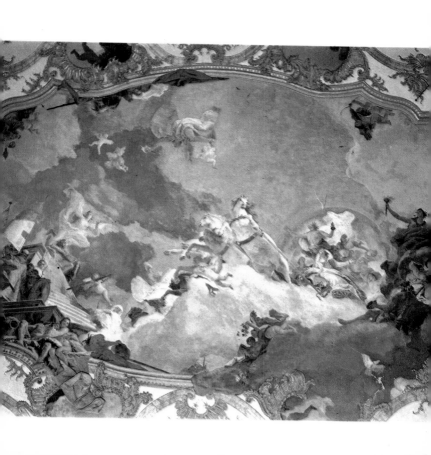

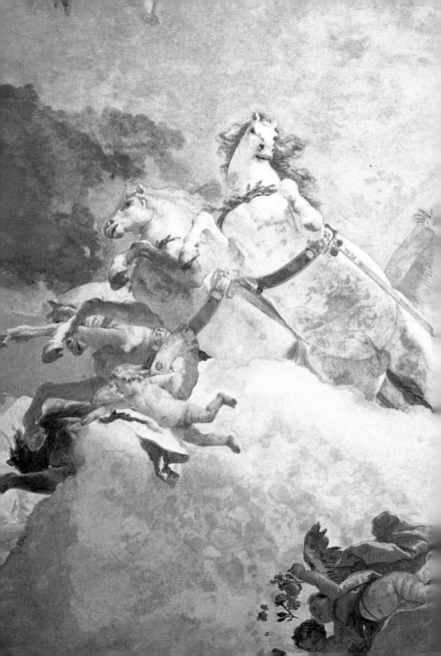

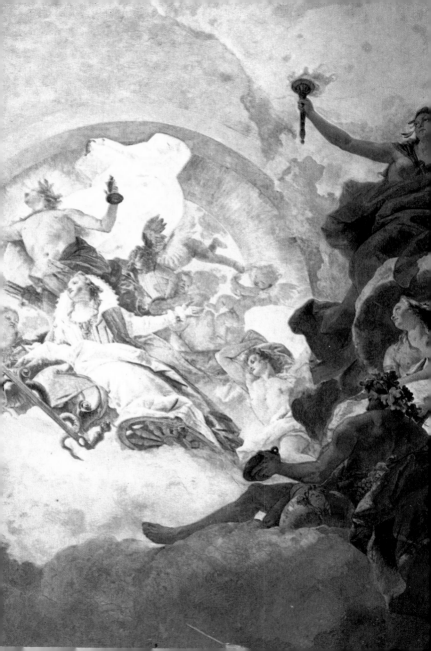

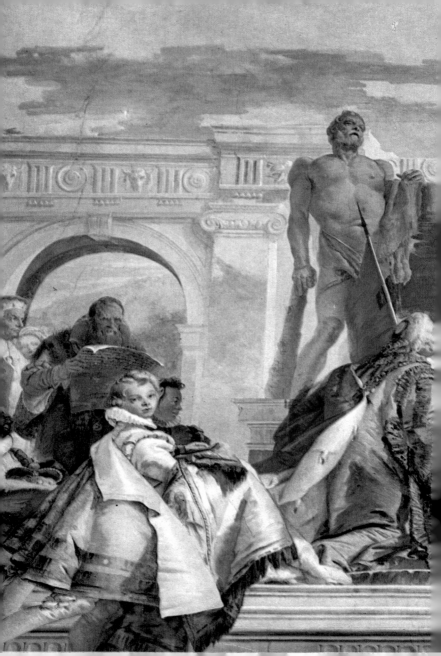

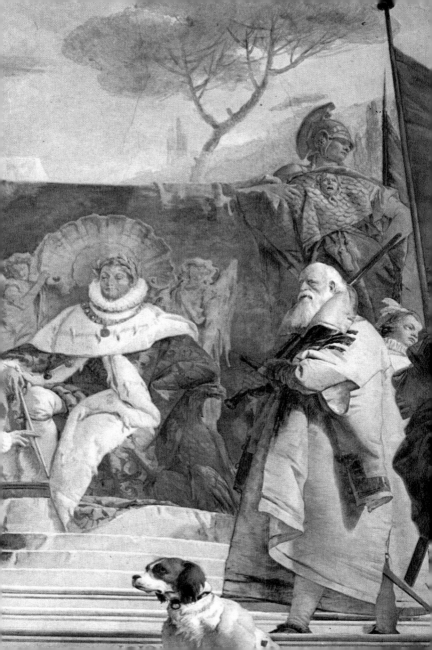

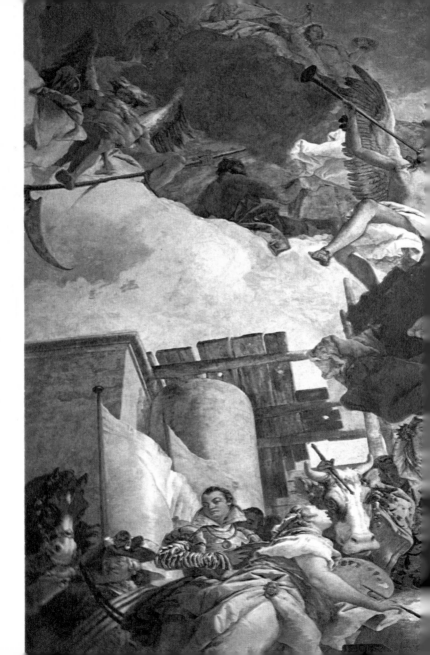

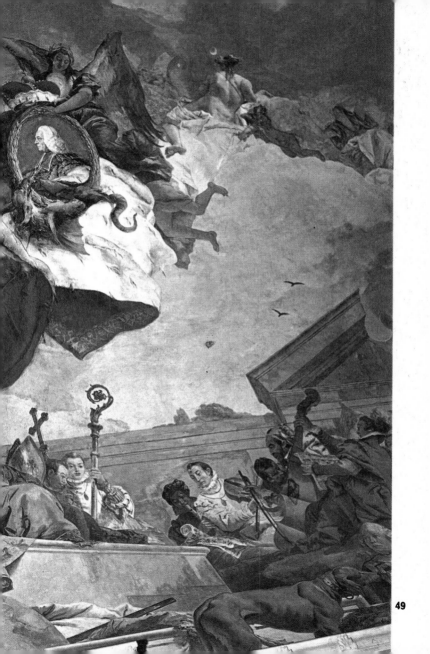

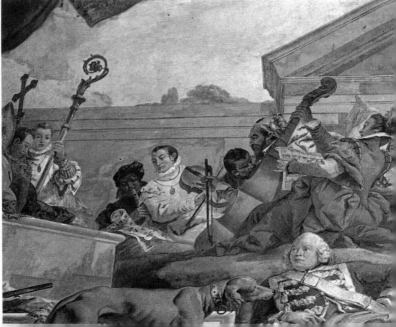

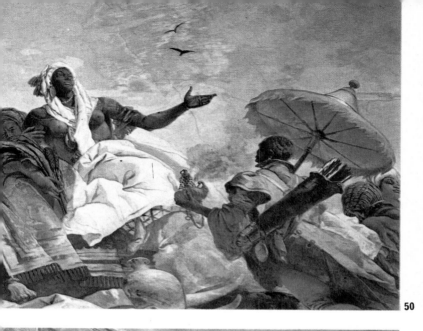

50

51

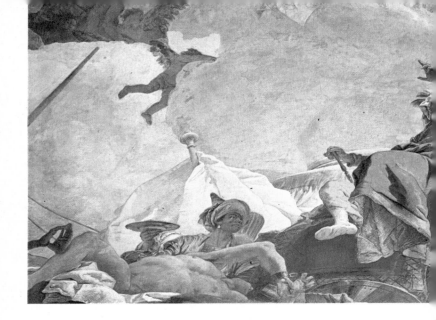

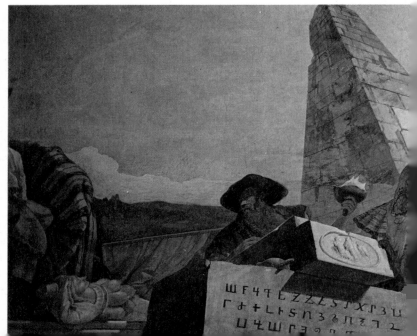

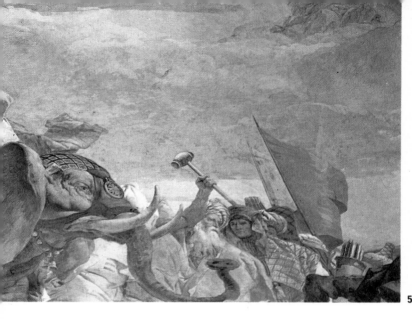

52

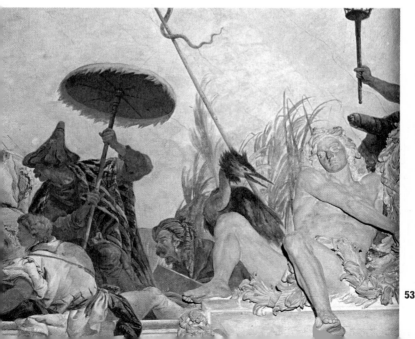

53

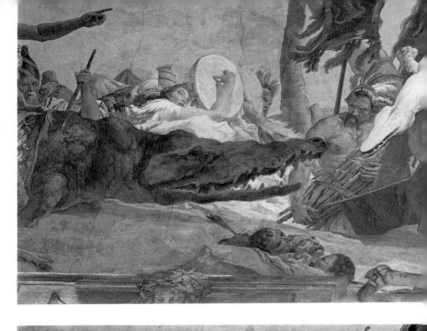

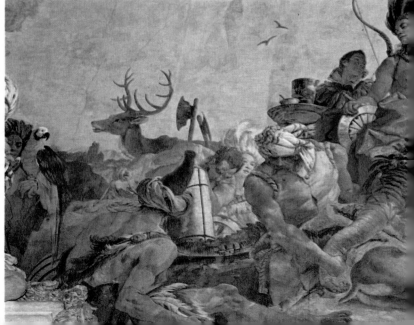

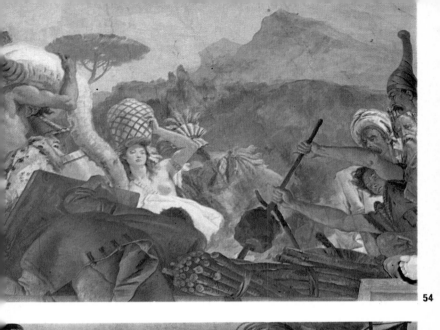

54

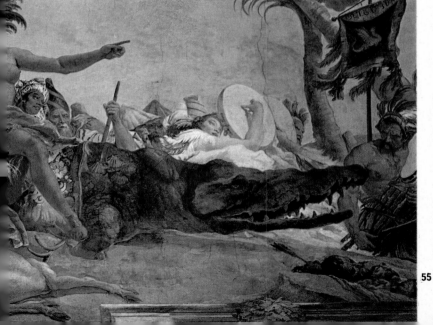

55

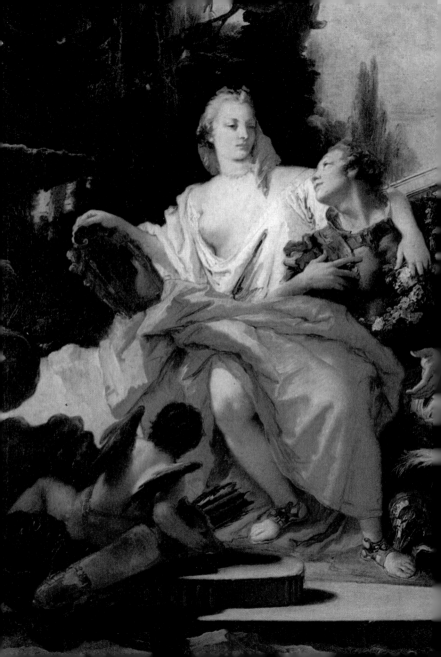

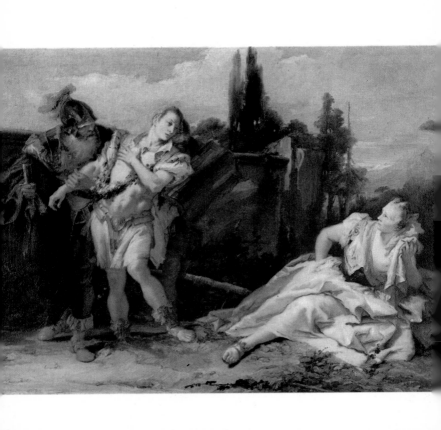

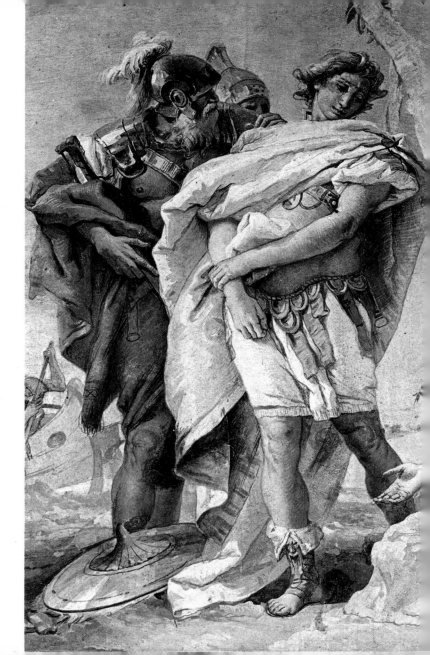

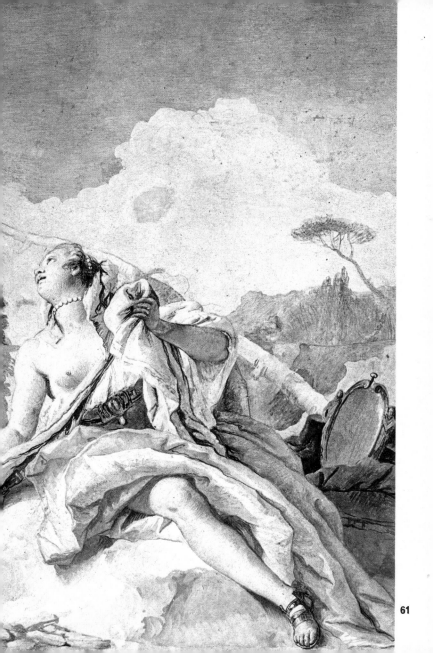

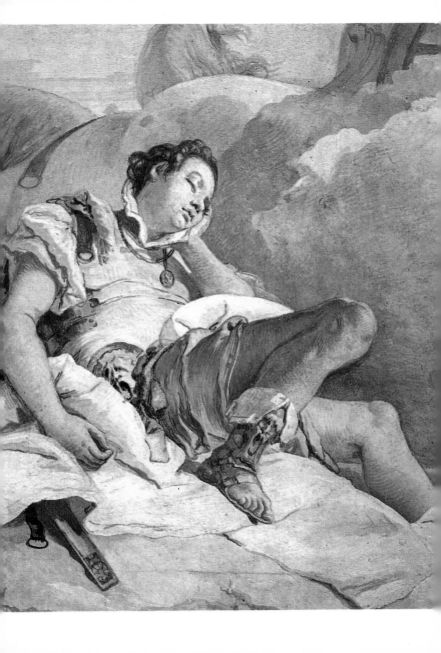

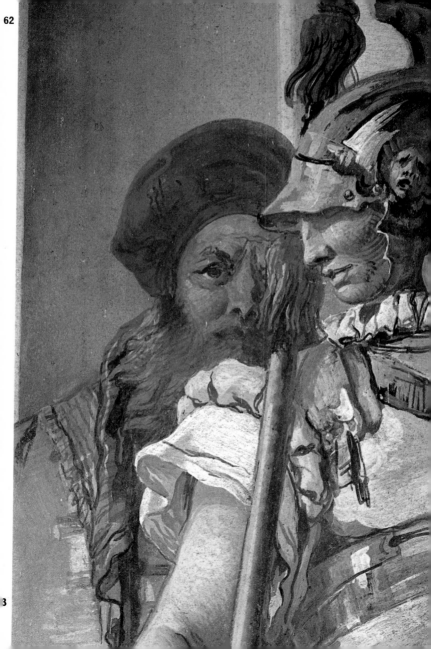

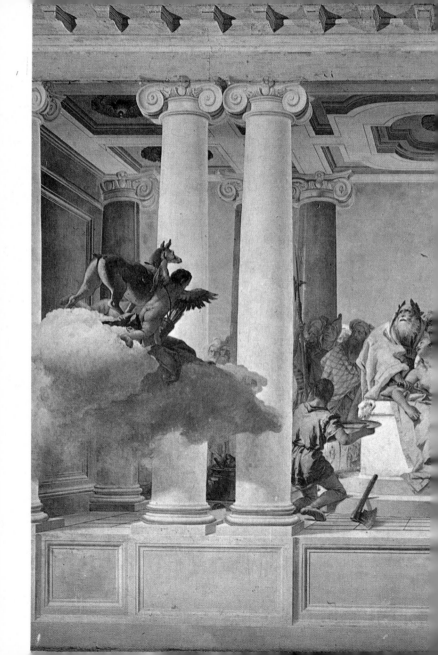

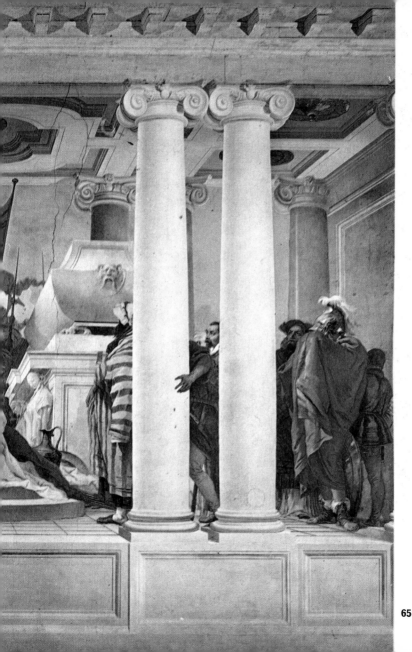

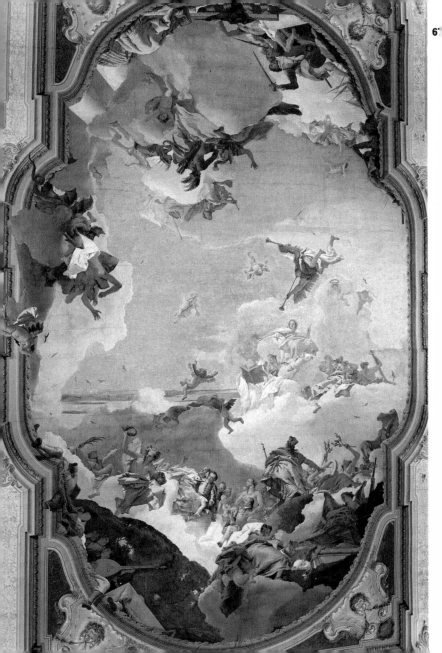

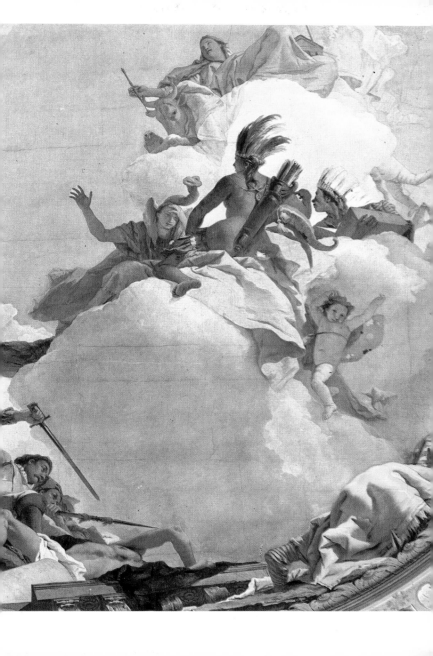

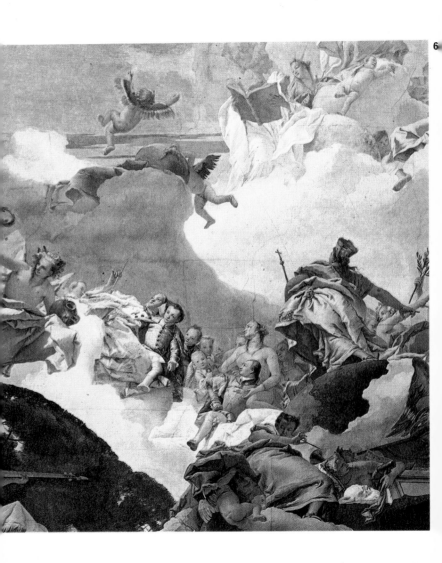

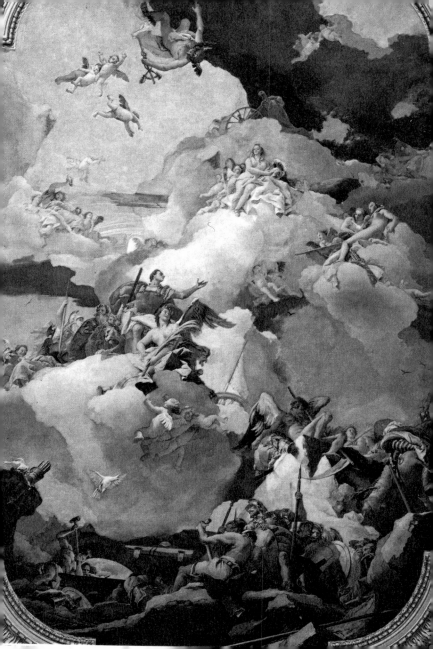

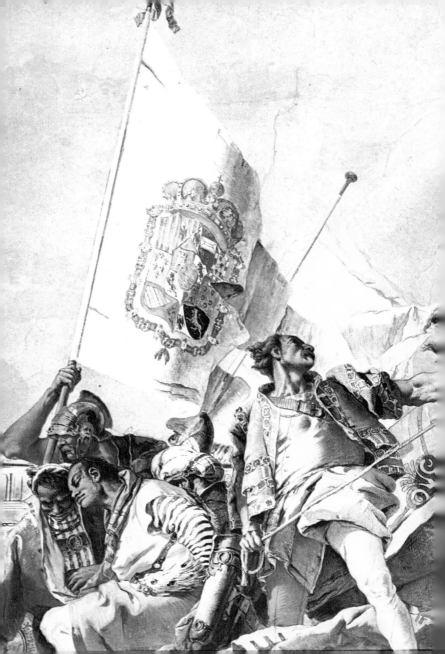

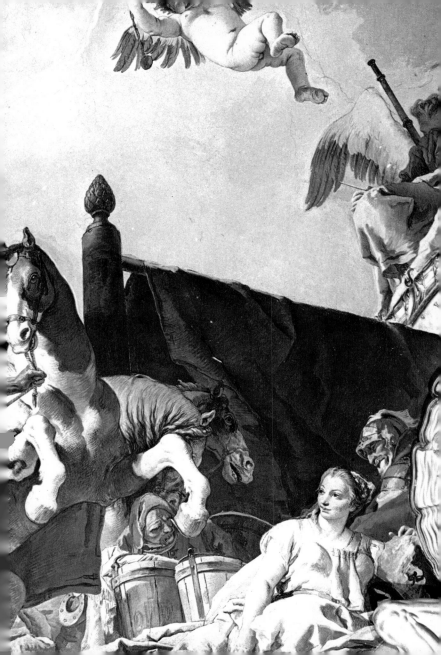

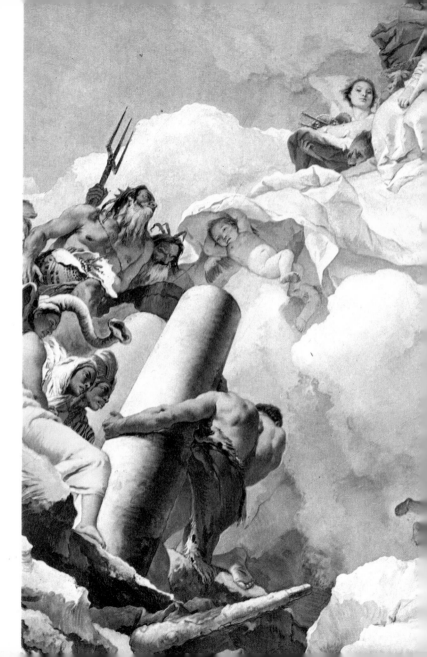

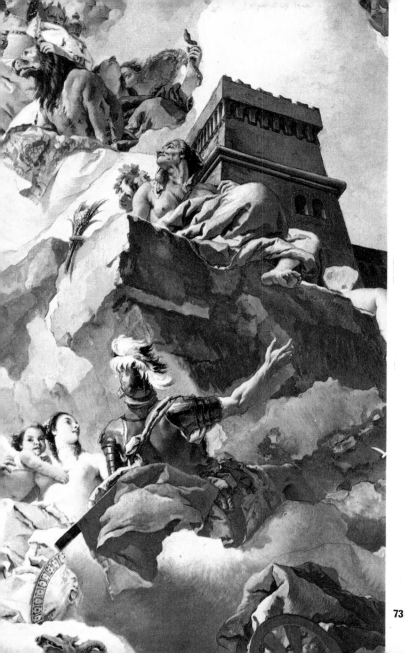

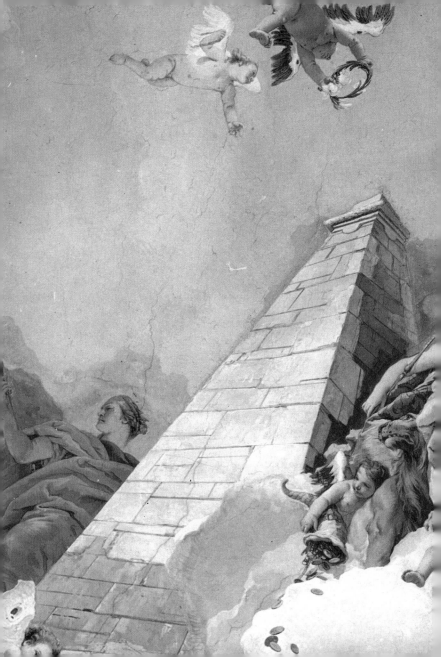

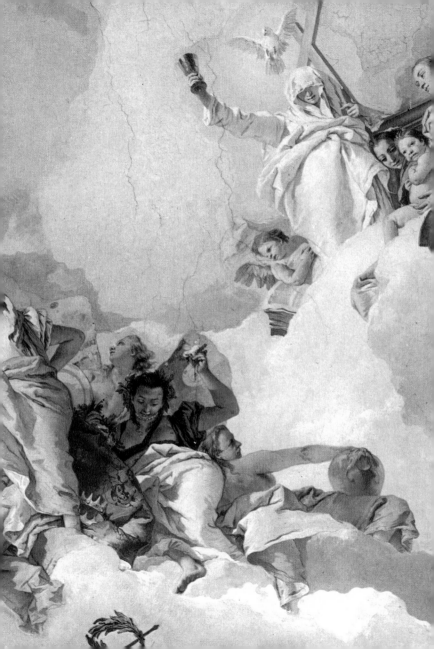

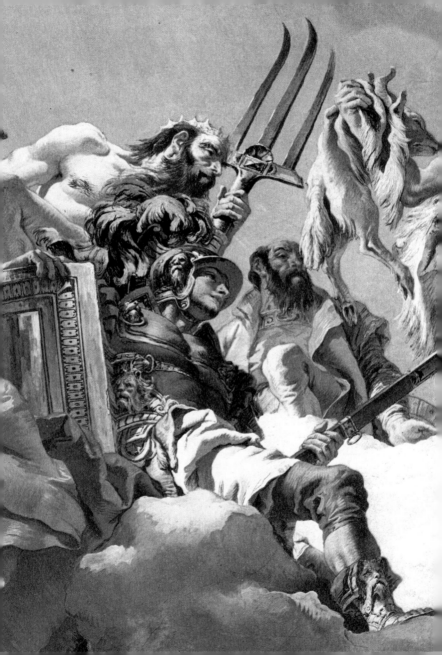

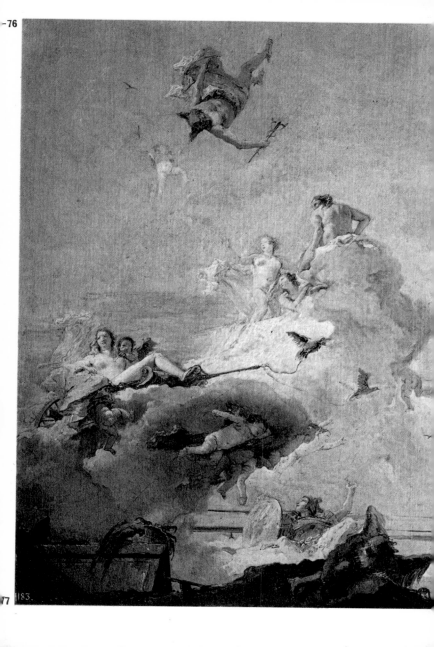